Impressionism

Kay Hyman

JG PRESS

DAWN OF MODERN ART

Impressionism

Contents

Published in the USA 1994 by JG Press
Distributed by World Publications, Inc
JG Press is a trademark of World Publications, Inc
455 Somerset Avenue, North Dighton, MA 02764
ISBN 0-9640034-7-3
North American Rights only

The Dawn of Modern Art
is an imprint of Cromwell Editions Limited and Ninic & Ninic
©*Text copyright by*
Ninic & Ninic and Cromwell Editions Limited

Designed by Paul McTurk BA MCSD
Printed by Tiskarna Ljudske Pravice, Slovenia

Introduction The name "Impressionism" was originally an insult, invented by an art critic who had a poor opinion of Claude Monet's painting *Impression – Sunrise*, exhibited at the first Impressionist Exhibition in 1874.

Impressionist painters were certainly interested in communicating "impressions", but the focus of attention of this innovative artistic movement was light. In the past landscapes had been formal, featuring history or mythology, and painted inside, in the artist's studio. The Impressionists painted outdoors, bringing freshness and spontaneity to real scenes from daily life that included the boulevards of Paris, the coast, sleepy villages, children playing in the park, events like picnics, regattas or horse races, or, indoors, social life in cafés, theatres and dance halls.

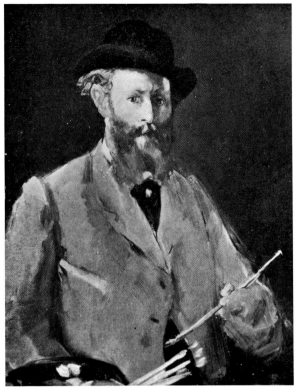

above Manet: *Self-Portrait*, 1875

below Pissarro: *Rue St Vincent, Montmartre*, 1860

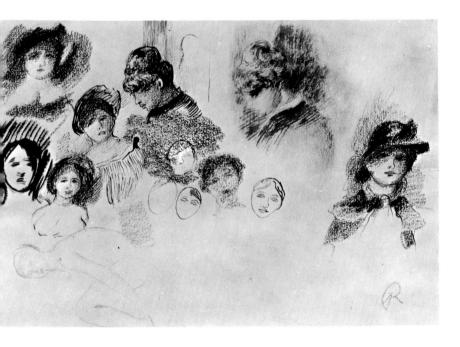

Renoir: *Heads of Women*

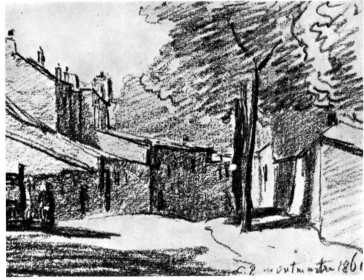

They used novel techniques to achieve lightness and purity of color, often stroking pure color straight onto the canvas and leaving the mixing normally done on the palette to the viewer's eye. Impressionists might align different shades of one color for emphasis, or many different colors together for effective depiction of light.

The Impressionists were a closely knit group that included Monet, Renoir, Pissarro, Sisley, Bazille, Morisot and Cassett. Manet and Degas were not genuine Impressionists, but were so closely entwined with the movement that they should be considered in the same context. The Impressionists' social focus was the Parisian Café Guerbois.

The Forerunners

Impressionism can conveniently be said to have begun in 1863 with the Salon des Refusés, the "Show of Rejected Artists". The Salon, the official art exhibition, had rejected a large number of submitted paintings, so Emperor Napoleon III demanded that a show be set up for them. This was a radical departure as the Salon had always had a stifling and traditionalist stranglehold on the French art world. Two of the artists exhibiting at the "alternative" venue were Eugene Boudin and Johan Barthold Jongkind, who, greatly interested in depicting light and conveying atmosphere, were founding fathers of Impressionism. They were practically unique in Europe in their practice of painting outdoors, to ensure the transmission of immediate "impressions" to the canvas. Boudin was a direct inspiration to the young Monet, who wrote of a painting trip they had both taken, "It was as if a veil had suddenly been torn from my eyes. I understood. I grasped what painting could really be." Boudin himself wrote, with undue modesty, "I may well have had some small measure of influence on the movement that led painters to study actual daylight and express the changing aspects of the sky with utmost sincerity."

Another exhibitor at the Salon des Refusés in 1863 was James McNeill Whistler, born in Massachusetts. He was not actually an Impressionist: he was interested in the effects of light but his work was far from spontaneous.

In his personal life a flamboyant dandy, his paintings could be sentimental – he was influenced by Courbet's realism and involved with the Pre-Raphaelites Rossetti and Swinburne in London.

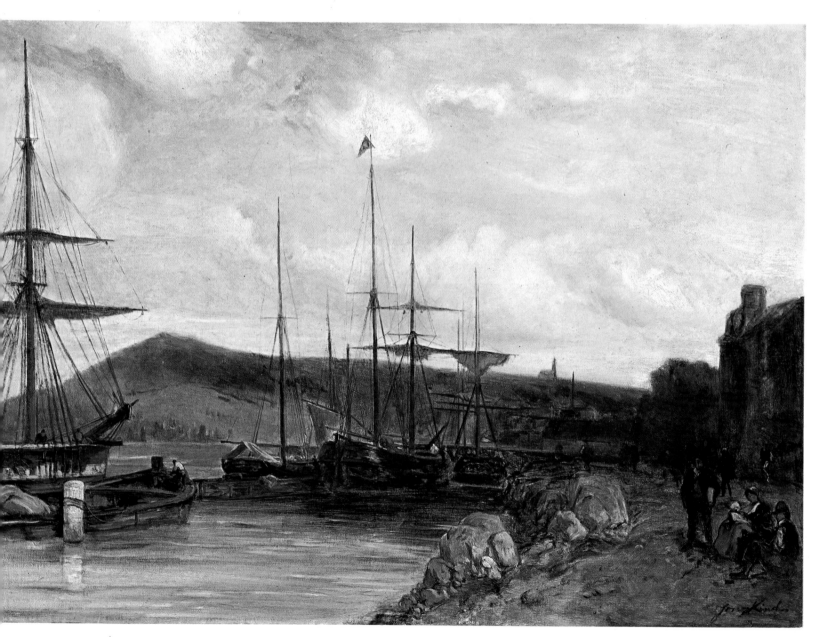

4

Johan Barthold Jongkind: *Harbor at Evening*

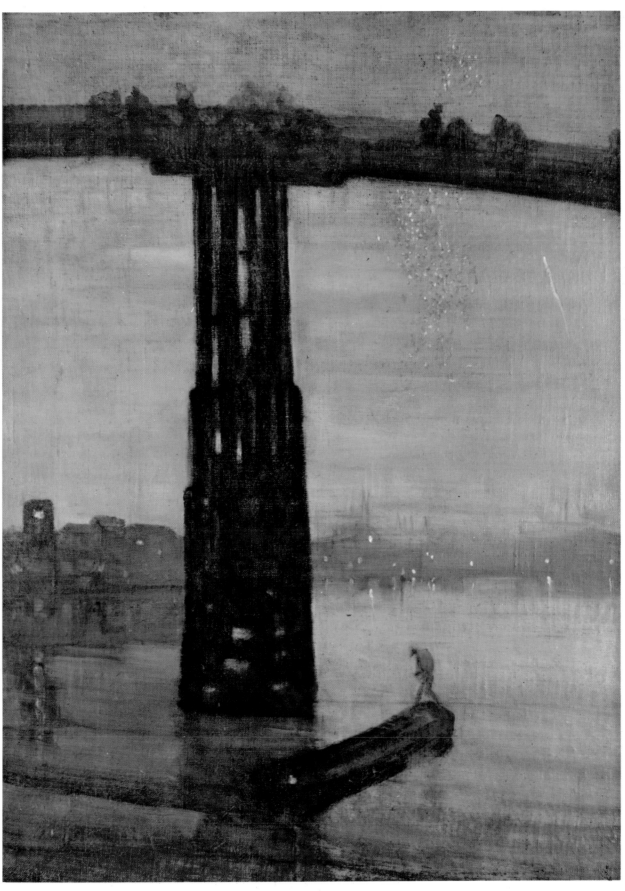

James McNeill Whistler: *Nocturne in Blue and Gold: The Old Bridge at Battersea*, c.1872-1875

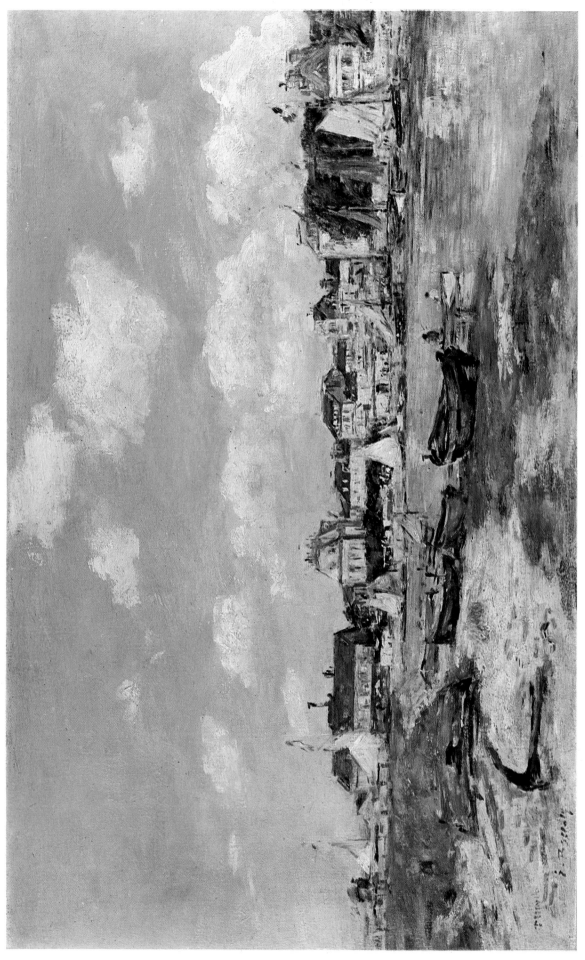

6 Eugene Boudin: *Trouville*, 1864

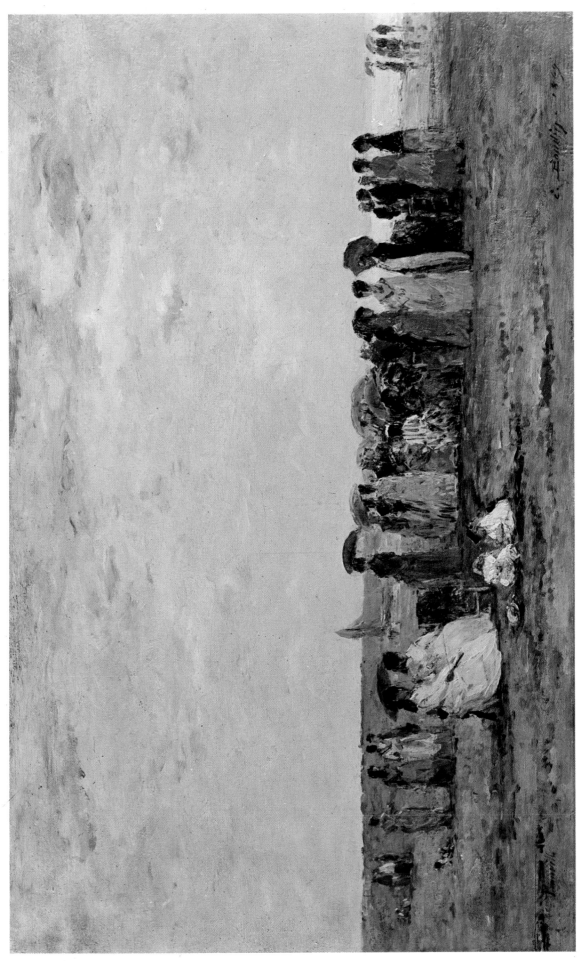

Eugene Boudin: *Bathers on the Beach at Trouville,* 1869

7

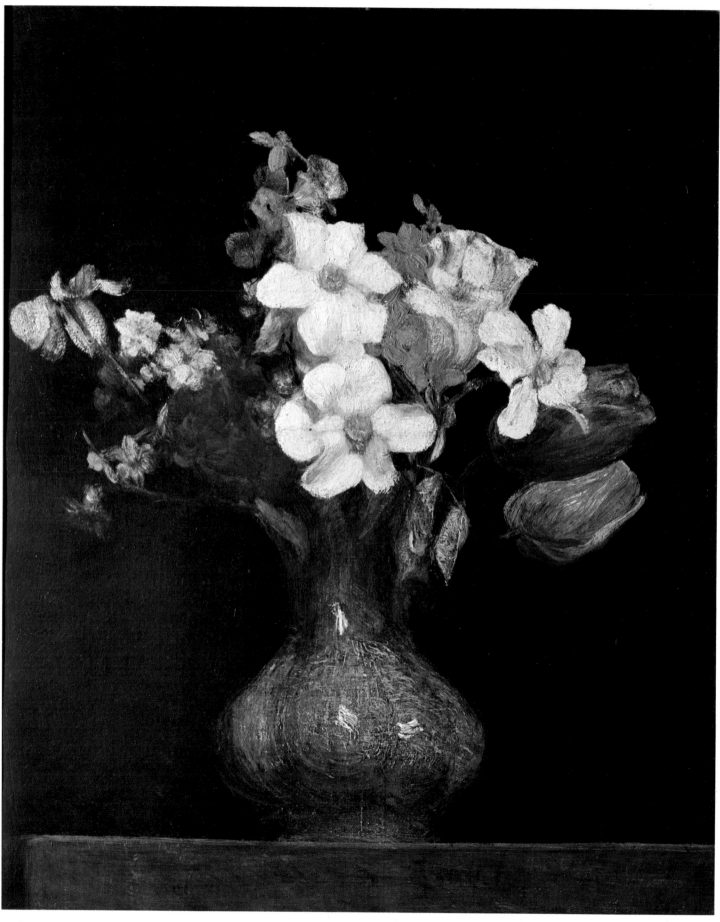

Henri Fantin-Latour: *Narcissus and Tulips,* 1862

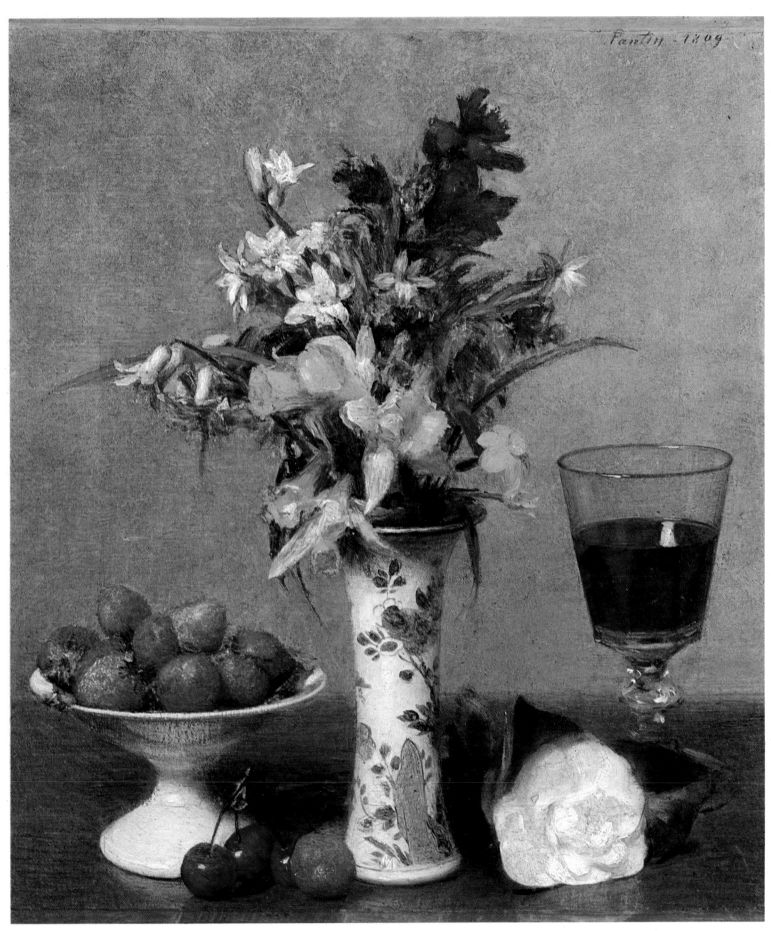

Henri Fantin-Latour: *"The Engagement" Still Life*, 1869 9

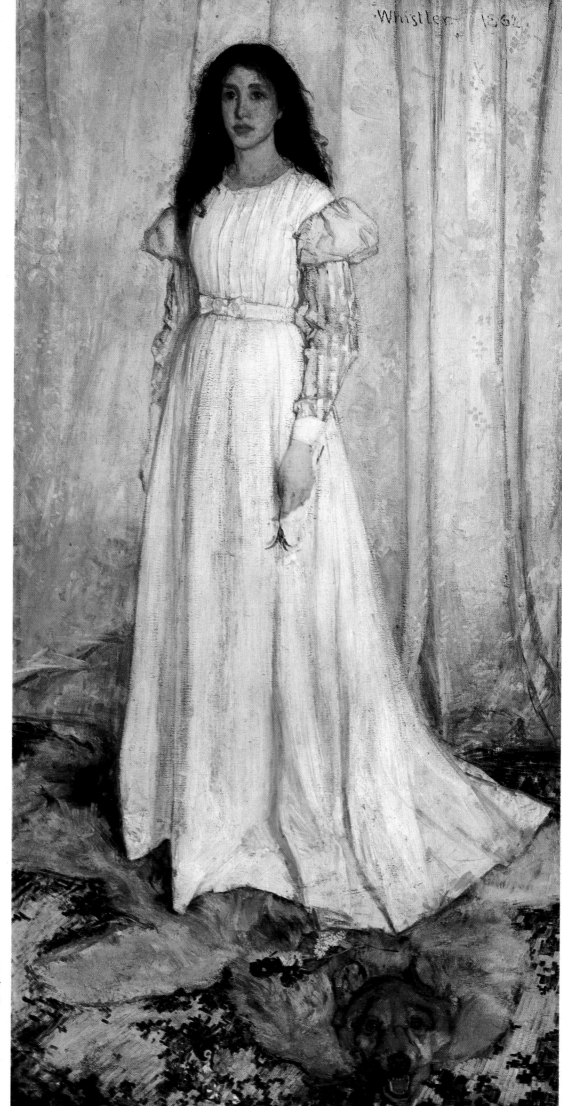

James McNeill Whistler:
Symphony in White No 1:
The White Girl, 1862

10

Edouard Manet

Most of the exhibits at the Salon des Refusés were uncontroversial or, at best, thought faintly ridiculous in their progressiveness. The exception was *Le Déjeuner sur l'Herbe*, by Edouard Manet (1832-83), which caused scandal by its depiction of two young men sitting on the grass fully clothed with a woman who is nude, while another woman returns lightly clad from bathing.

The root cause of the outrage was the realistic portrayal of the naked woman, shocking to a public accustomed to seeing only mythological or historical figures in such a state. Manet's intentions had been operating on a quite different, non-literal, level: he had made his own arrangement of subject matter drawn from Giorgione's painting *Concert Champàtre,* combined with a composition inspired by Raphael. Giorgione's *Sleeping Venus* was the basis for another controversial Manet painting,

of the provocative and very "real" Olympia. In this case also, what was not appreciated was that Manet was exploring an art historical motif, not literally portraying real life.

The widespread derision aroused by the Salon des Refusés was not an entirely negative effect, however, as it brought the new, if generally incomprehensible, departures in painting into the public arena. It made Manet's reputation and, also in 1863, he exhibited, at his first one-man show in Paris, *Concert in the Tuileries Gardens*, a comfortable, bourgeois subject that reflected Manet's prosperous and fashionable background.

A wild radical in the opinion of the public, Manet was, paradoxically, regarded as a traditionalist by younger painters. At this stage he was still not painting out of doors – a fact obvious from the unconvincing light in *Le Déjeuner sur l'Herbe.*

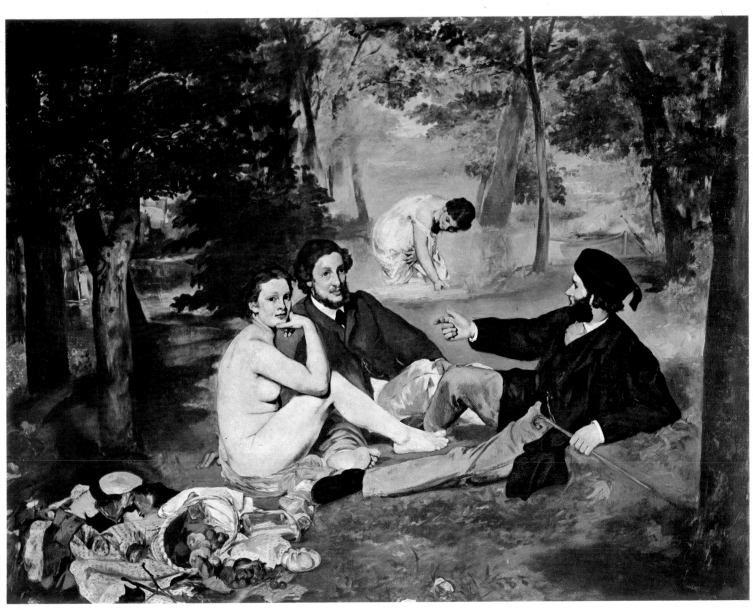

Edouard Manet: *The Picnic,* 1862-1863

The influence of the Impressionists, particularly Manet, finally led him to take to the fresh air and "free up" his style, though he retained his emphasis on formal composition, and never exhibited with the Impressionists, retaining his allegiance to the Salon.

Just before his death Manet painted *A Bar at the Folies-Bergére*, with its carefully arranged lights, forms and textures and literally impossible reflections.

The bar-maid's reflection is at the wrong angle, the reflection of her customer is too big, and the reflected bottles do not match those on the counter. Like all Manet's work this is a dazzling impression of an unreal world. As Degas said, "A painting is an artificial work existing outside nature, and it requires as much knavery, trickery, and deceit as the perpetration of a crime."

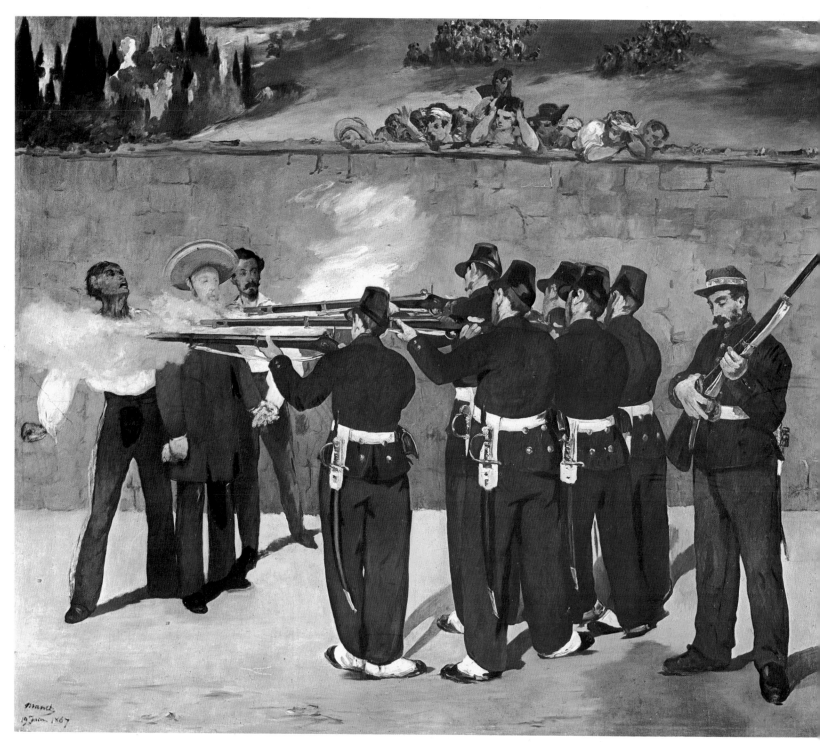

12

Edouard Manet: *Execution of the Emperor Maximilian*, 1867

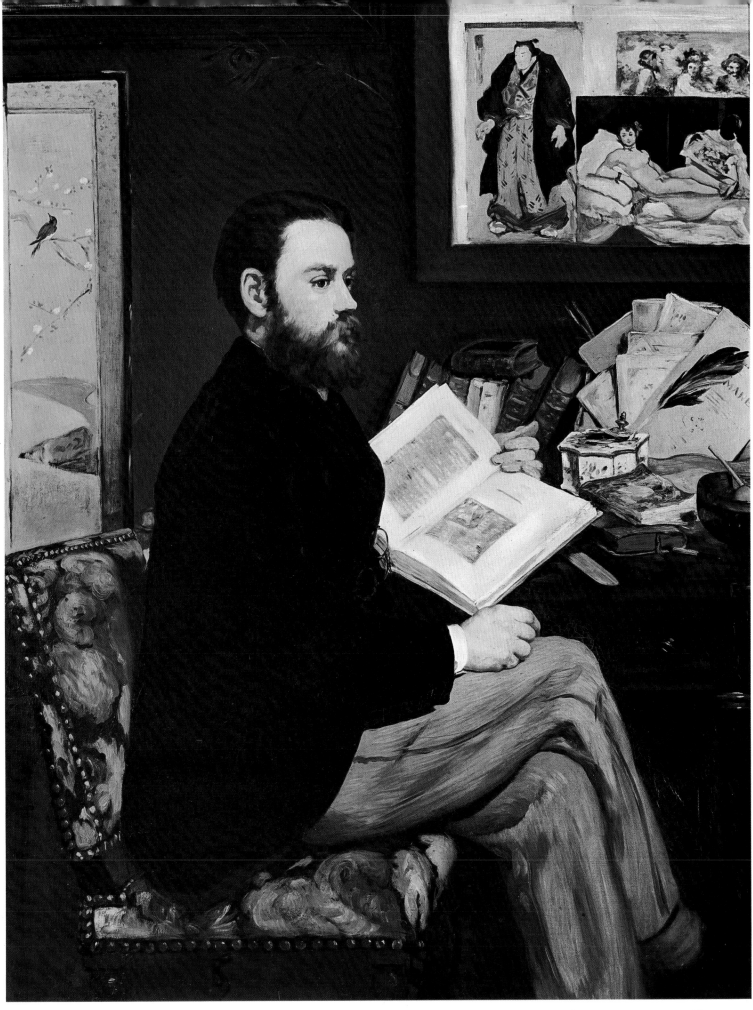

Edouard Manet: *Portrait of Emile Zola,* 1868

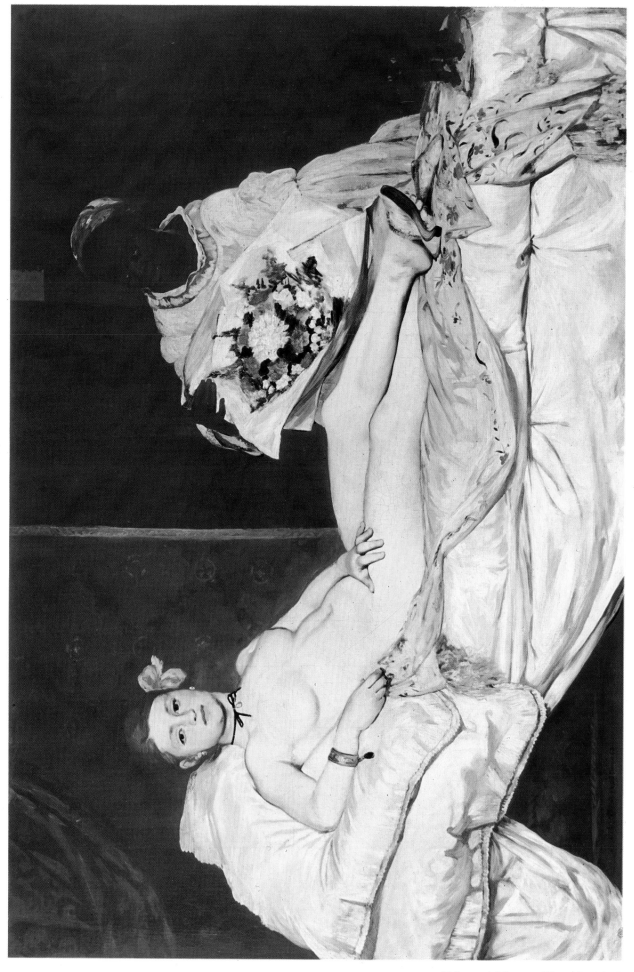

14 Edouard Manet: *Olympia*, 1863

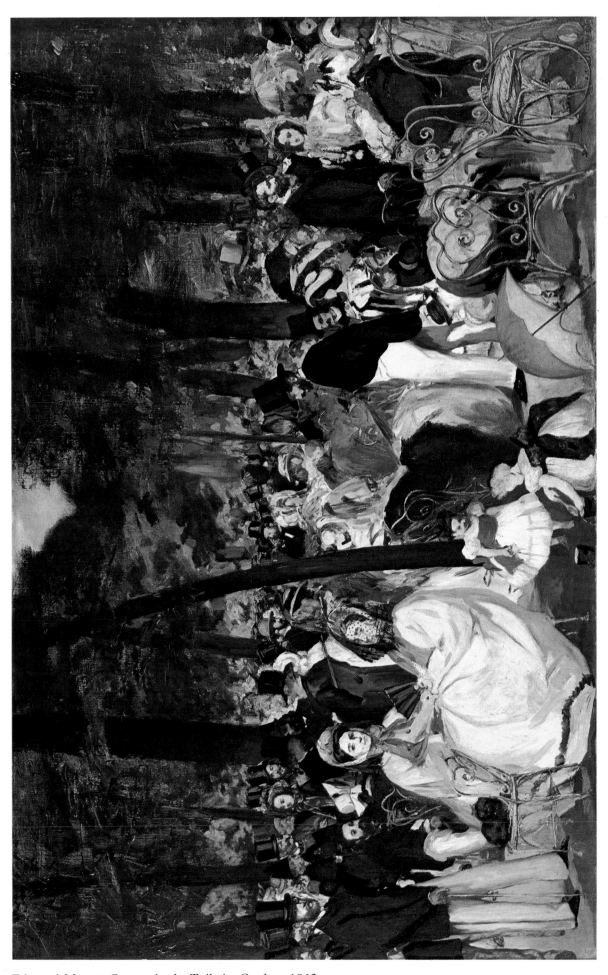

Edouard Manet: *Concert in the Tuileries Gardens*, 1862

15

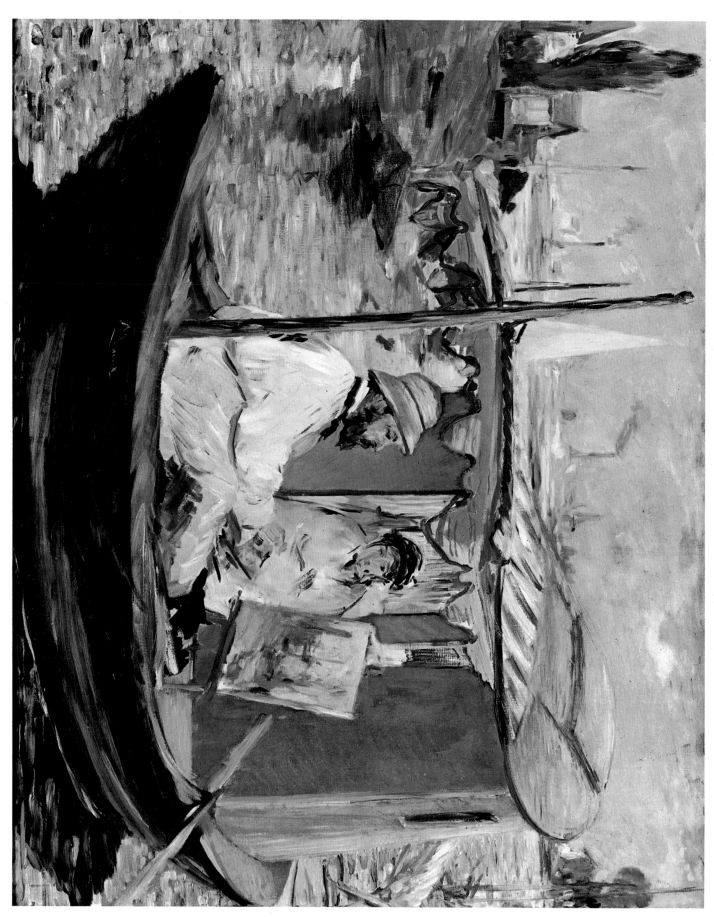

16 Edouard Manet: *Claude Monet Working on His Boat in Argenteuil,* 1874

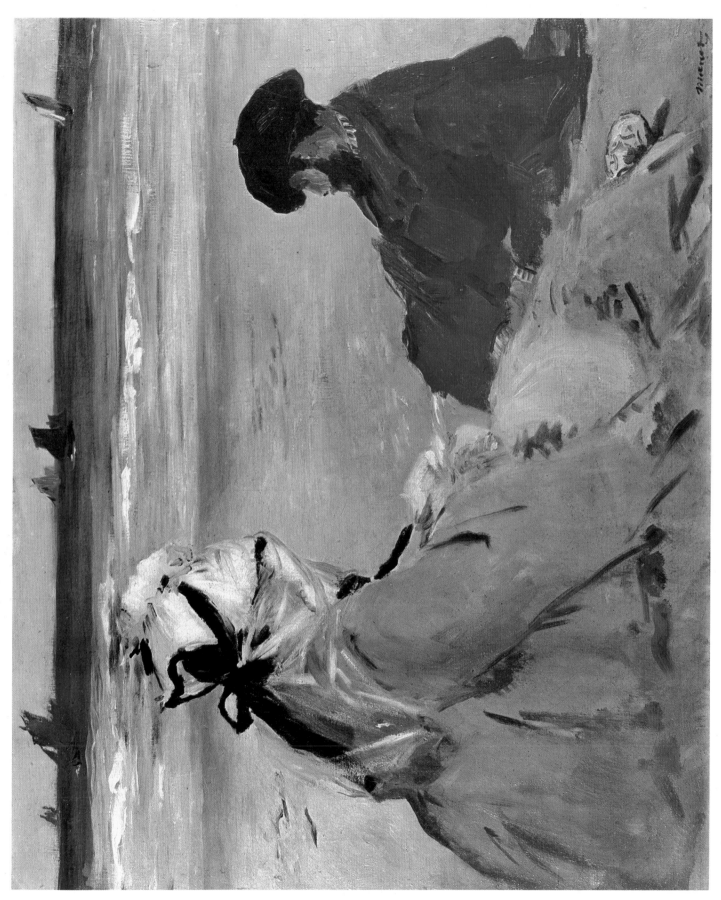

Edouard Manet: *On the Beach*, 1873

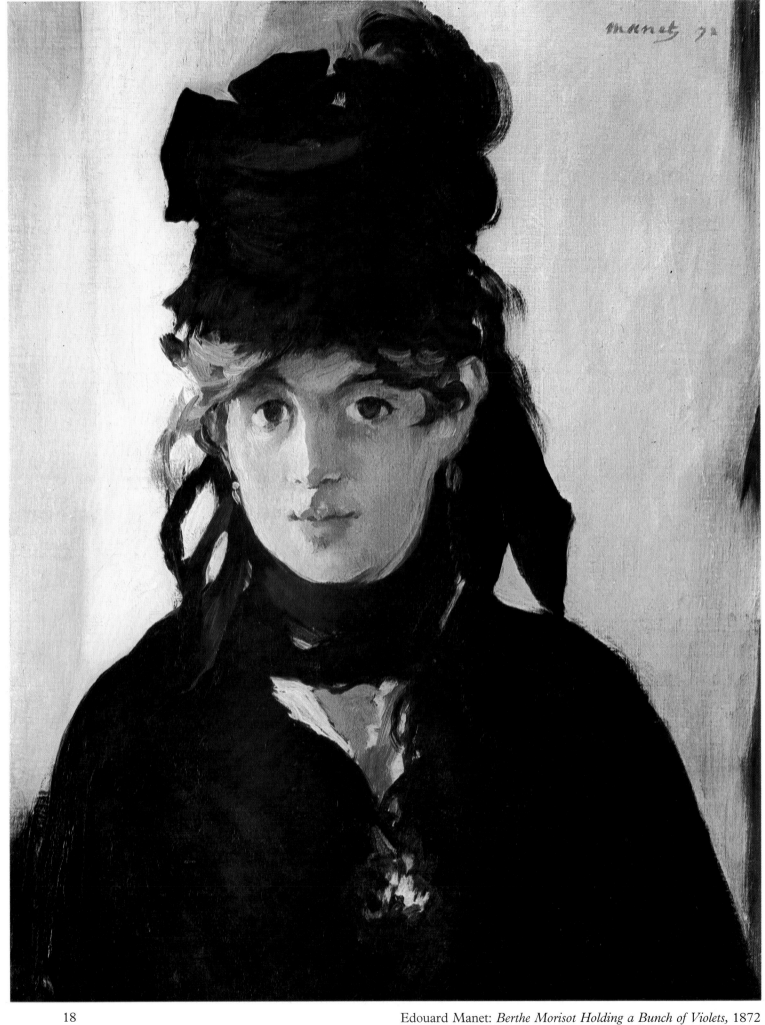

18 Edouard Manet: *Berthe Morisot Holding a Bunch of Violets*, 1872

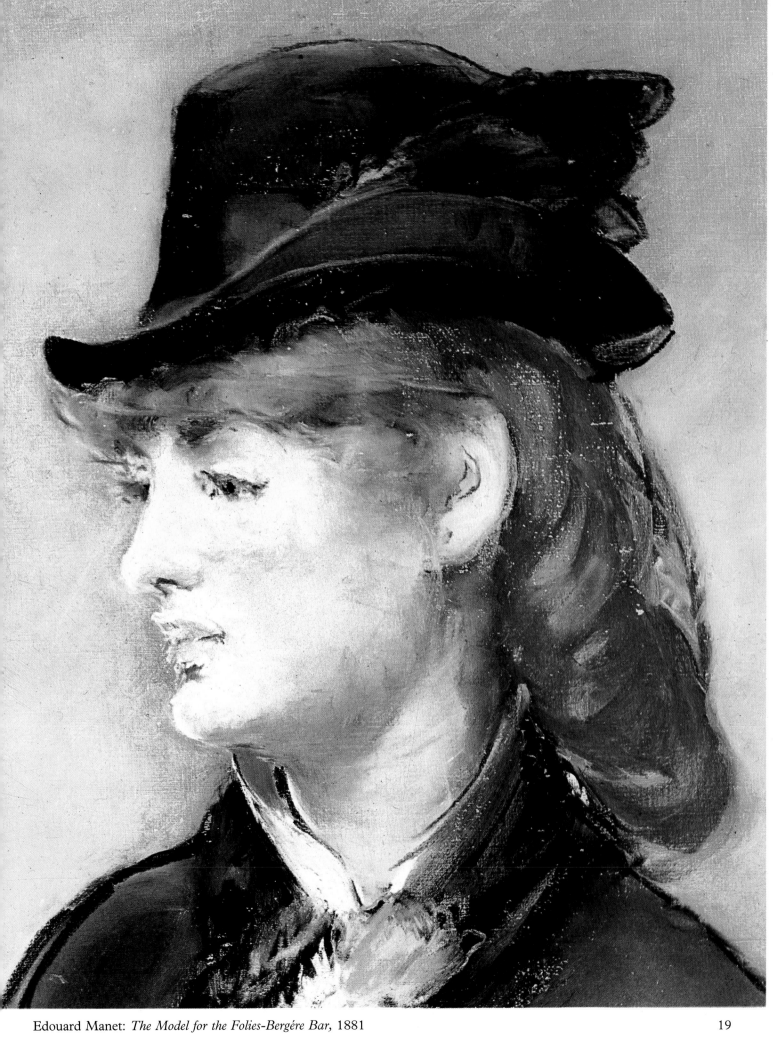

Edouard Manet: *The Model for the Folies-Bergére Bar*, 1881 19

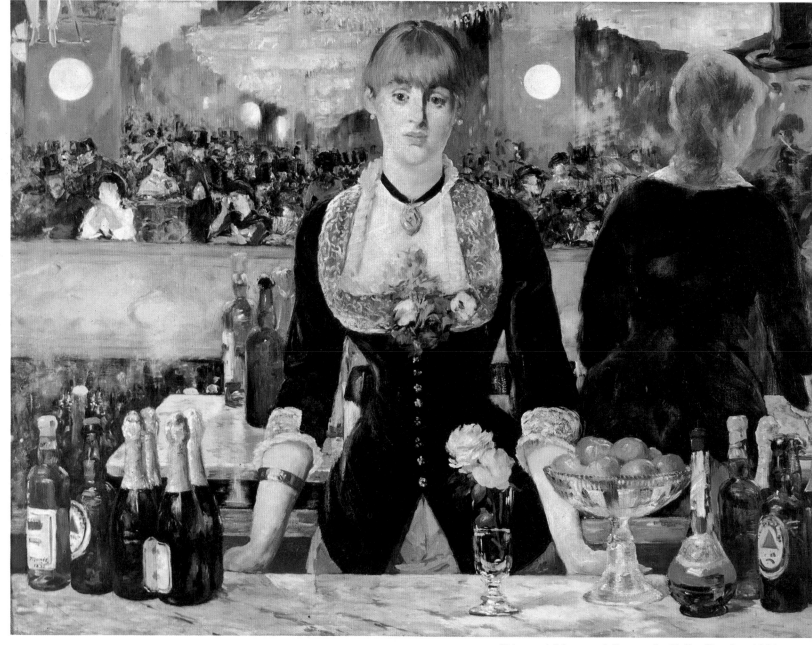

Edouard Manet: *A Bar at the Folies-Bergére*, 1881

Edgar Degas

Degas (1834-1917), a friend of Manet's, began his artistic career with great admiration for Italian painters. He painted his aunt and her family, *The Bellilli Family*, while studying in Florence. His strength in composition and the prominence of character in a natural setting are notable even at this early stage. Returning to Paris, he became friendly with Manet, whose work was similar in many respects, except that Degas stressed line where Manet emphasised color. Degas's concern was specifically with people, and he often depicted revealingly what might normally be thought clumsy, for example the sitting ballerina in *The Rehearsal* and *After the Bath: Woman Drying Her Feet.* Degas differed widely from the Impressionists.

Like Manet initially, he did not work outdoors, not greatly interested in capturing shining sunlight and capricious atmosphere.

He concentrated on line, which the Impressionists abandoned, and his work was carefully composed, though it could look spontaneous, with unusual perspective and angle of view.

It is interesting to note that Japanese prints were an important influence on his composition. *Café Concert at les Ambassadeurs*, with great care, diagonally aligns the line of lights with the singer's outstretched arm. This intersects with another diagonal formed by her other arm and more lights to focus the whole painting on her face.

20

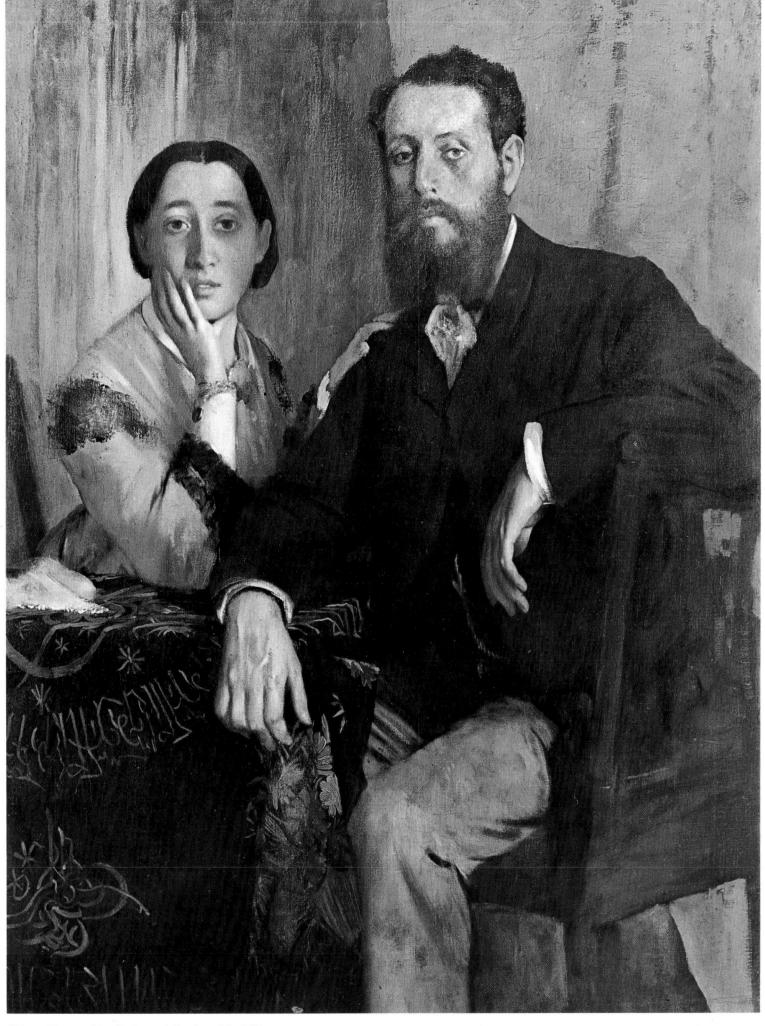

Edgar Degas: *The Duke and Duchess Morbilli* 21

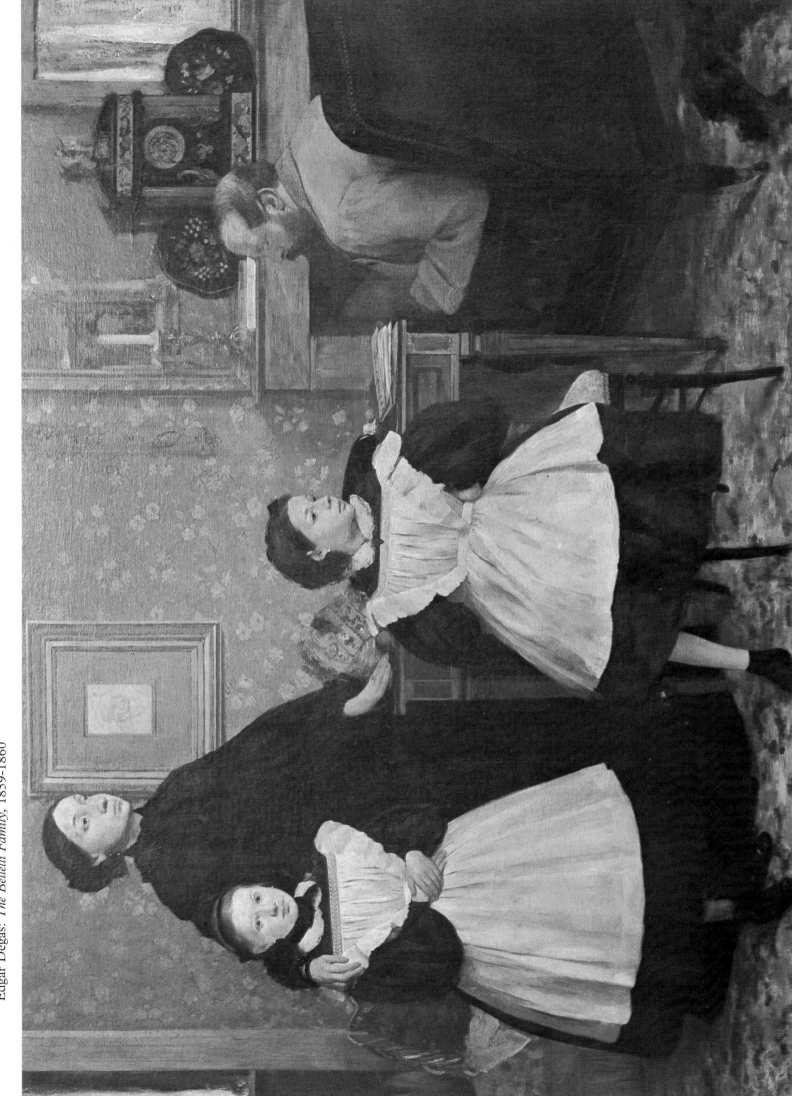

Edgar Degas: *The Bellelli Family*, 1859-1860

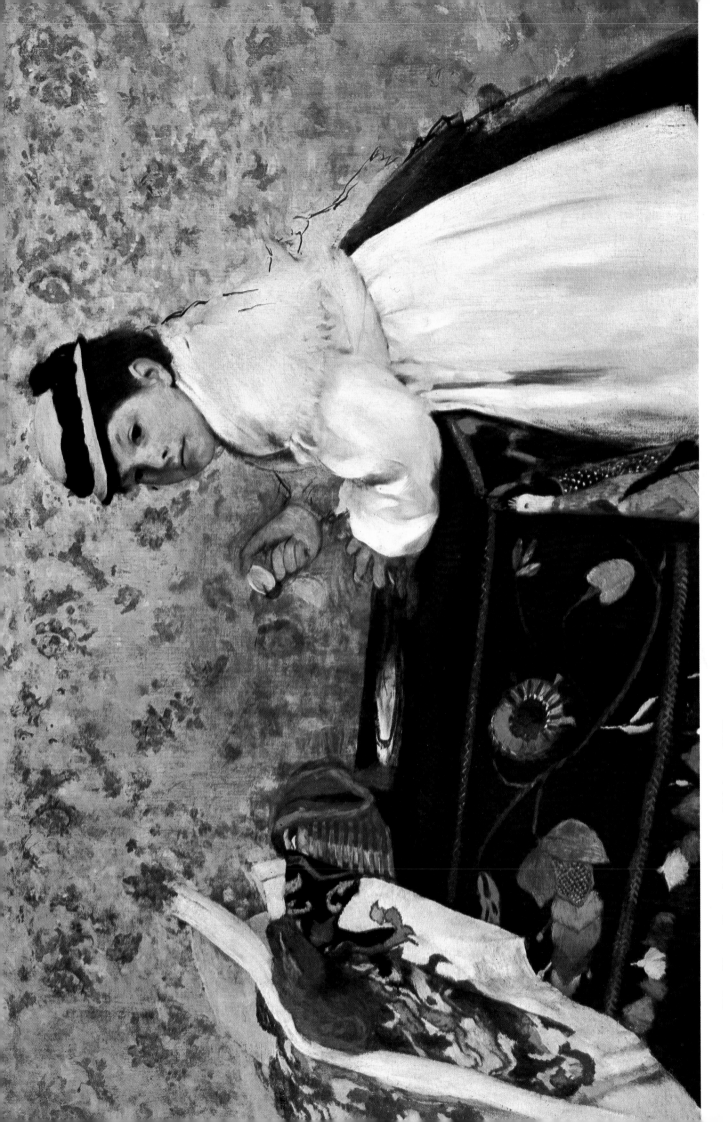

Edgar Degas: *Portrait of Hortense Valpinçon*, 1869

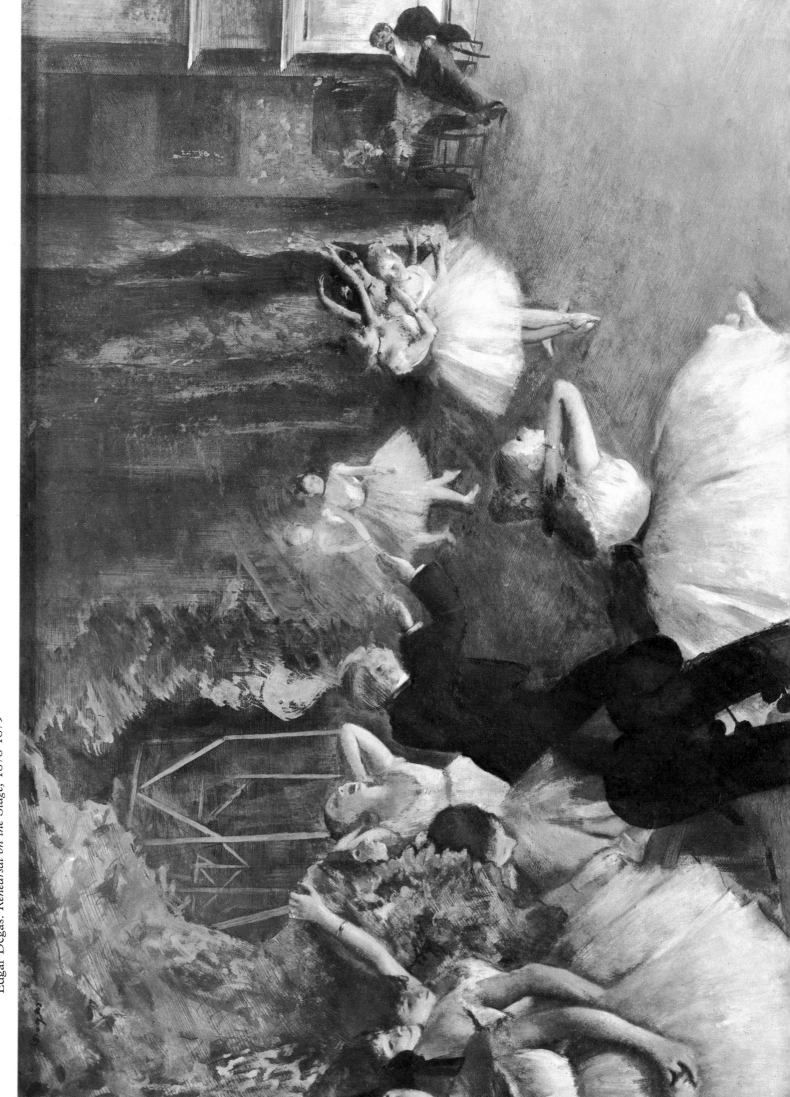

Edgar Degas: *Rehearsal on the Stage, 1878-1879*

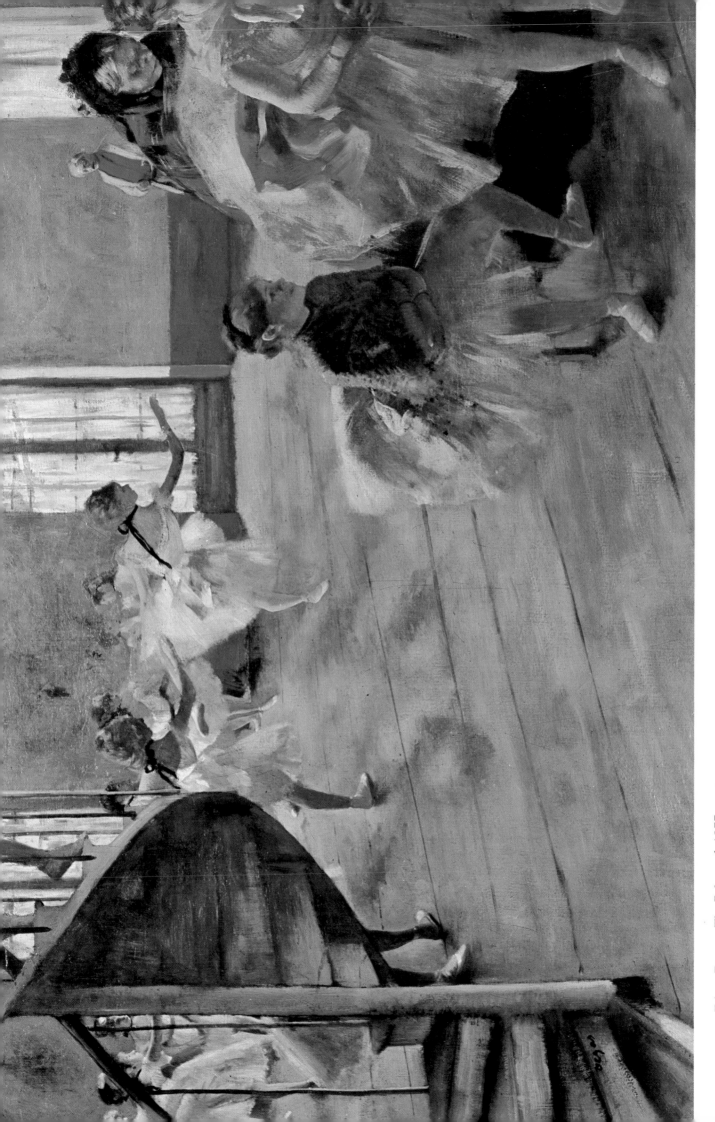

Edgar Degas: *The Rehearsal*, 1877

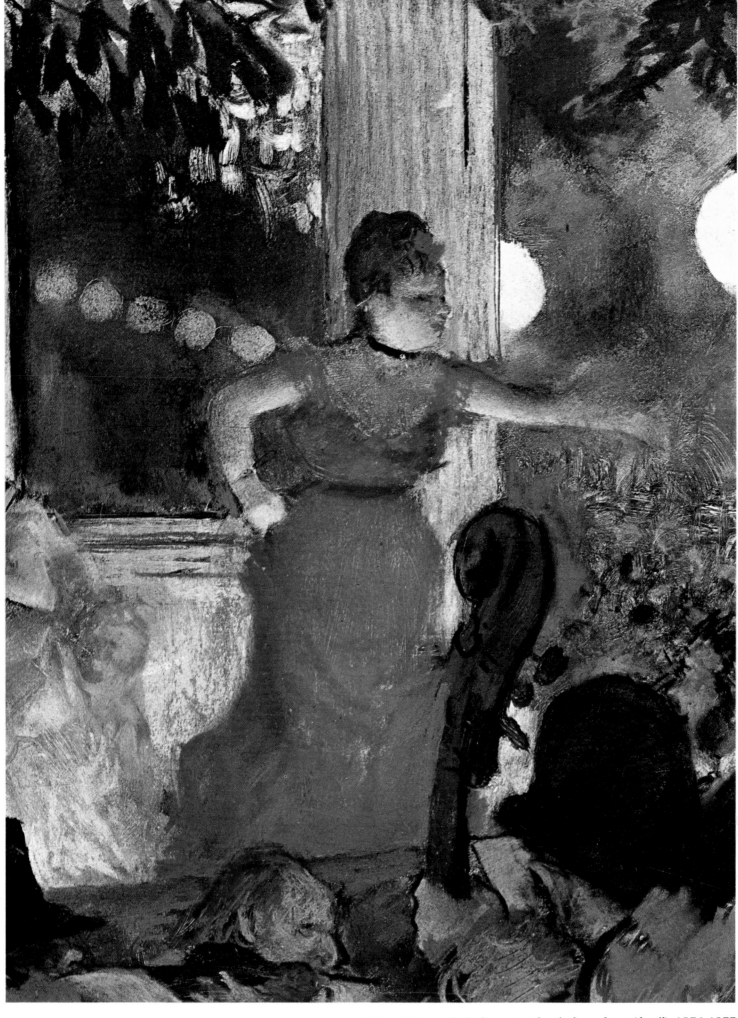

26 Edgar Degas: *Café Concert at les Ambassadeurs (detail)*, 1876-1877

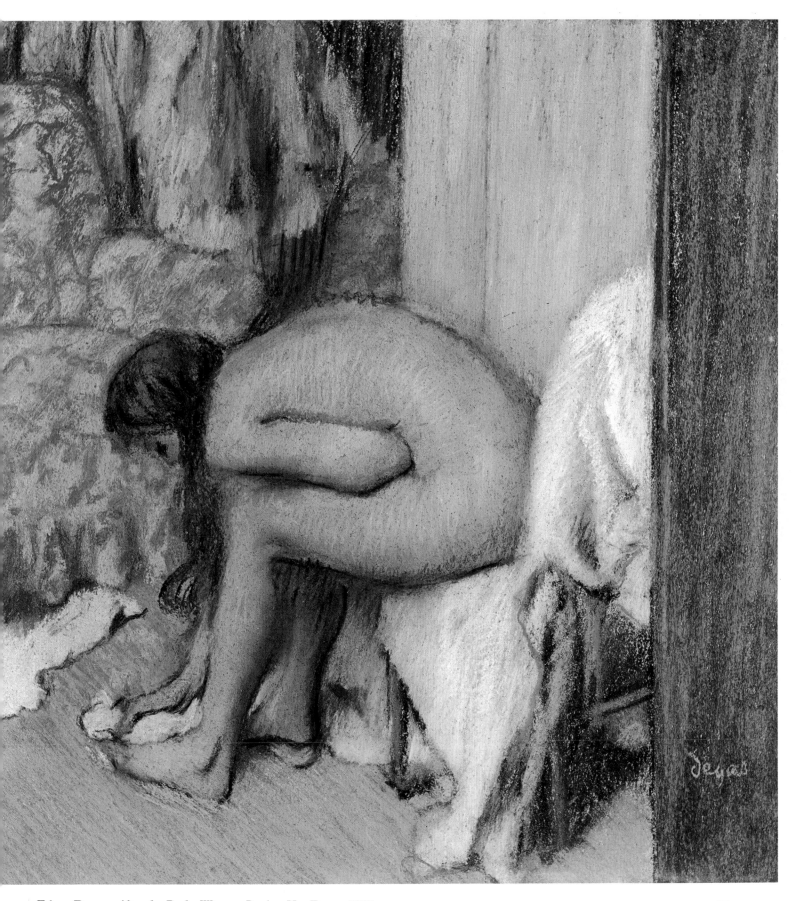

Edgar Degas: *After the Bath: Woman Drying Her Feet*, c.1886

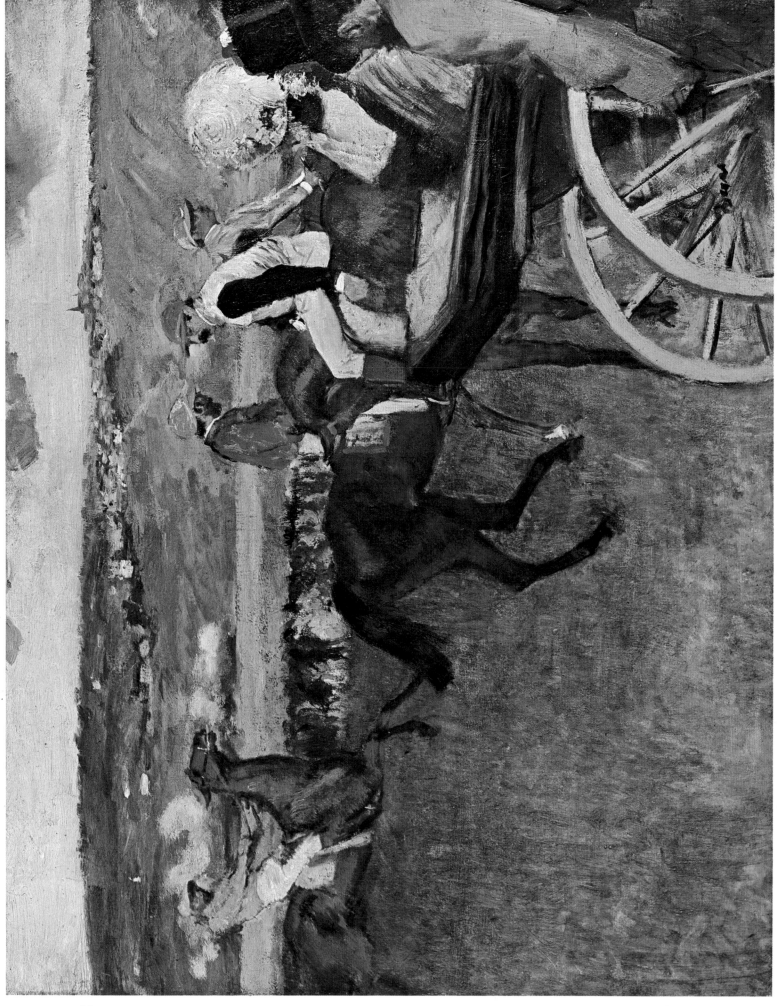

28 Edgar Degas: *At the Races,* 1877-1880

Claude Monet

The artist considered the archetypal Impressionist is Claude Monet (1840-1926).

In his youth he painted outdoors with Boudin and Jongkind and made many groundbreaking discoveries about the use of color. He realised that color is ubiquitous, existing even in the most profound shadow, that objects juxtaposed donate color to one another and that complementary colors are mutually enhancing. Monet's series of paintings of the facade of *Rouen Cathedral* in different kinds of light was inspired by Jongkind, thirty years before, painting two pictures of a cathedral, in the morning and in the evening.

Monet painted a number of other series along the same lines: haystacks, the Thames and, finally, in almost abstract mode, the waterlilies in his garden at Giverny.

In 1862 Monet enrolled for instruction at the studio of Charles Gleyre, where he joined Renoir, Sisley and Bazille in revolt against their more conventional teacher. Manet's great fame after the 1863 Salon des Refusés led Monet to paint a picture with the same name.

In comparison with Manet's original the figures and background are more unified, and the whole work is more redolent of the outdoors. (Only two pieces of this large painting survive as Monet deposited it with another painter as security for rent he could not afford to pay, it was left rolled up and decomposed).

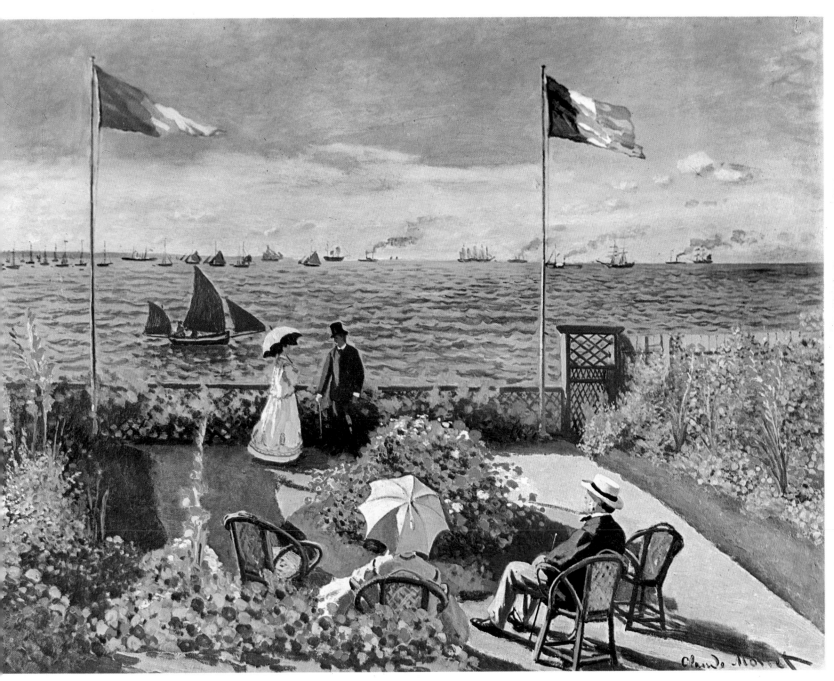

Claude Monet: *Terrace at St Adresse,* 1866

Monet's first major Impressionist works were painted on the Seine, in a boat-cum-studio, where he often painted with Renoir and Manet. They demonstrate his discovery that colors combined by the "eye of the beholder" are much more vibrant than those mixed physically: blue applied next to yellow results in a much more brilliant green.

Monet suffered a great deal in the course of his career. Continued lack of acceptance left him in acute poverty which, in combination with illness in his family, led to periods of acute despair.

These black moods, however, were never reflected in his paintings: for example, the cheerful *Rue Montargueil with Flags* was done during a very bleak phase. Eventually Monet's tenacity was rewarded and in his last years he enjoyed success, his achievement acknowledged.

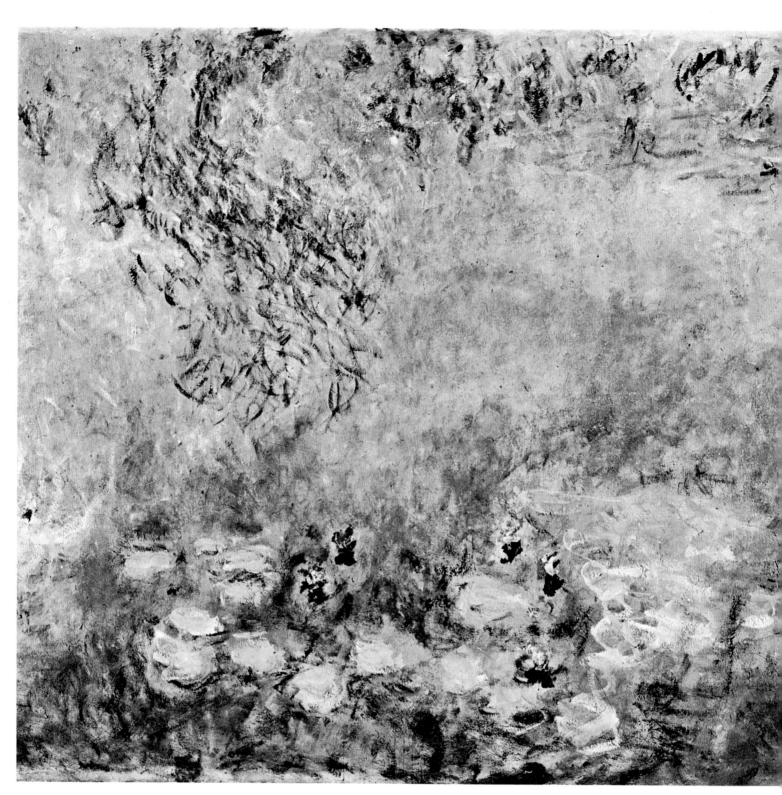

Claude Monet: *Waterlilies (detail)*, 1910

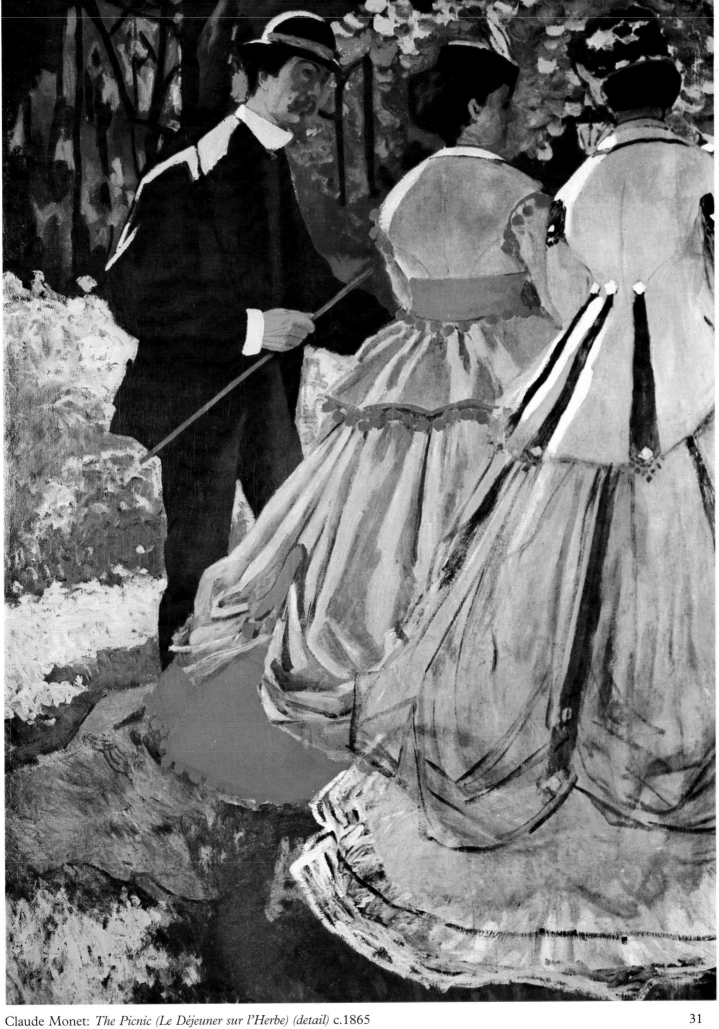

Claude Monet: *The Picnic (Le Déjeuner sur l'Herbe) (detail)* c.1865

32 Claude Monet: *The Studio-Boat, c.*1874

Claude Monet: *La Grenouillère*, 1869

34

Claude Monet: *Regatta at Argenteuil*, 1874

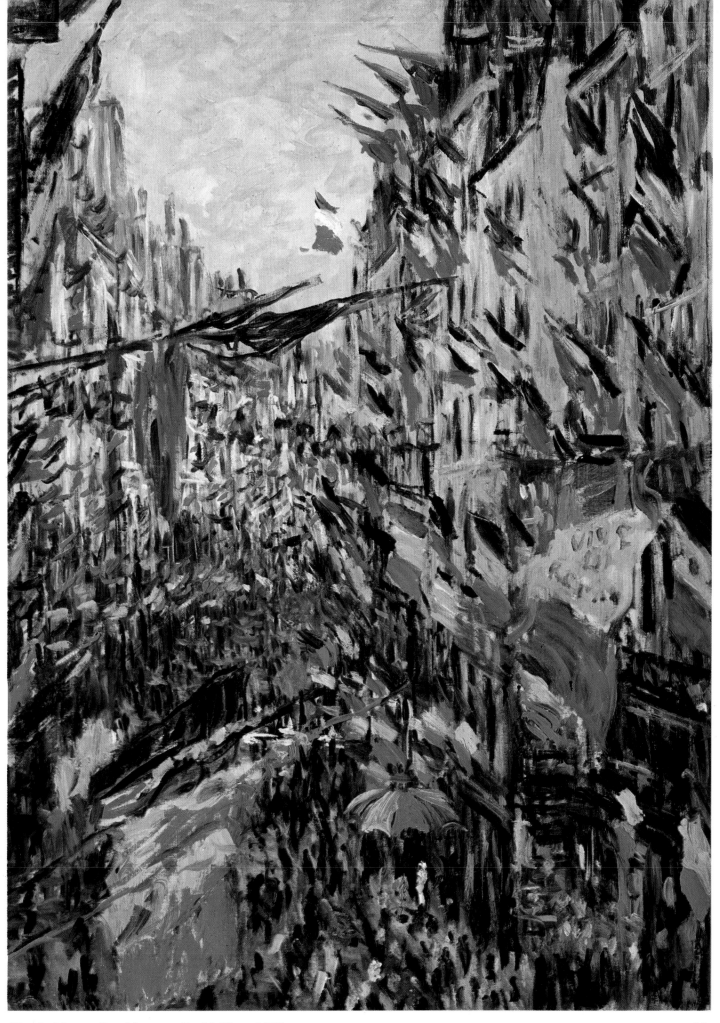

Claude Monet: *Rue Montargueil with Flags*, 1878

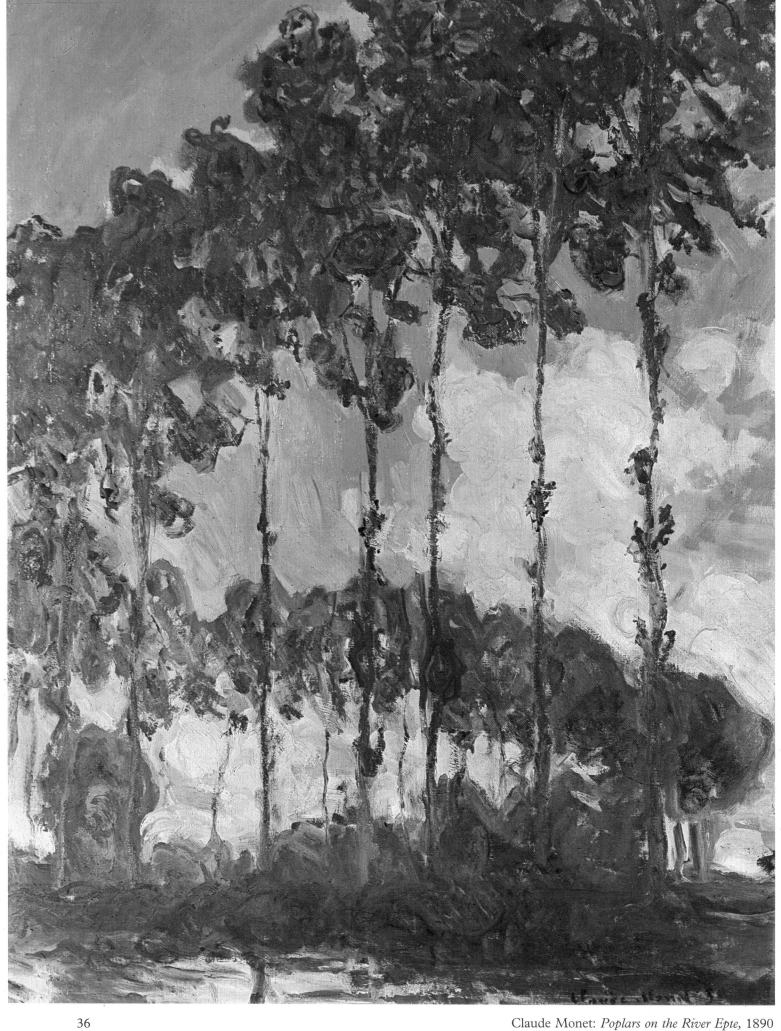

36 Claude Monet: *Poplars on the River Epte*, 1890

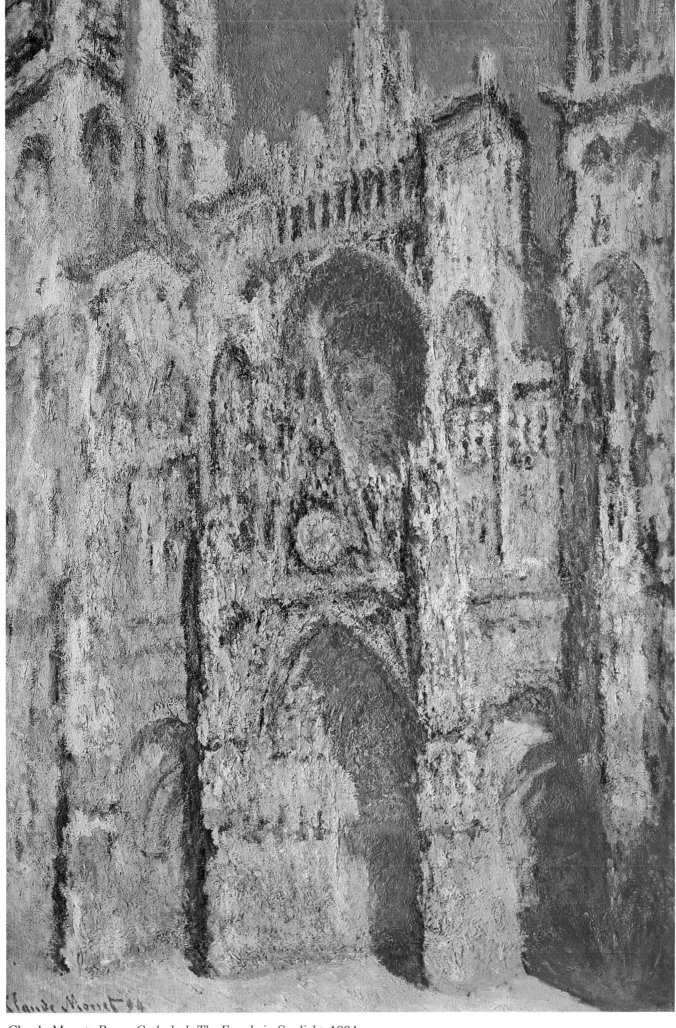

Claude Monet: *Rouen Cathedral: The Façade in Sunlight*, 1894

Pierre Auguste Renoir

The joyful qualities of the paintings of Pierre Auguste Renoir (1841-1919) led to his relatively rapid acceptance by the public. Initially, he and Monet had very similar styles and frequently painted together – but Renoir was attracted to the charming sensuality of the eighteenth century which is reflected throughout his work in colors and textures: a woman's pearly- smooth skin, transparent silk fabric, flower petals. (It is no doubt significant that in his youth Renoir had worked as a decorator of porcelain, fans, and silks.) The Impressionist preoccupation with light is, however, still apparent in his painting and is used to unify figures and their environment, as in *The Swing* and *Le Moulin de la Galette*.

His style eventually changed, becoming more solid, after he encountered Raphael's painting and Pompeiian frescoes on travels in Italy in 1881.

Renoir was no intellectual, and disdained art theory, but his good-natured personality did much to improve the somewhat sinister Bohemian image of the Impressionists. His attitude has been described as that of "an adolescent who glories in luscious food and plump, pink girls."

Renoir enjoyed professional and financial success, continuing until the end of his life to be enthusiastically creative and productive, ultimately, with severe rheumatism, painting with a brush strapped to his arm.

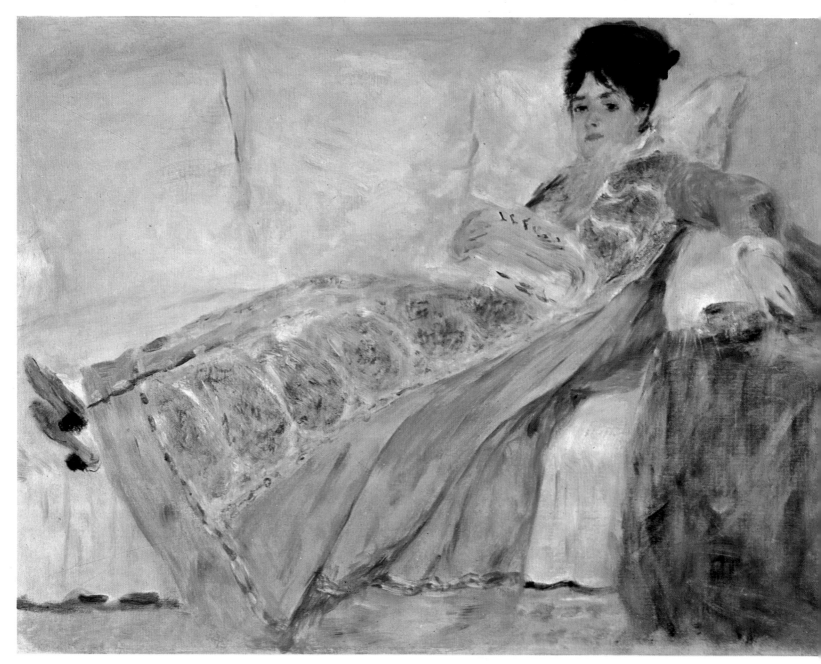

Pierre Auguste Renoir: *Madame Monet Reading, "Le Figaro,"* 1874

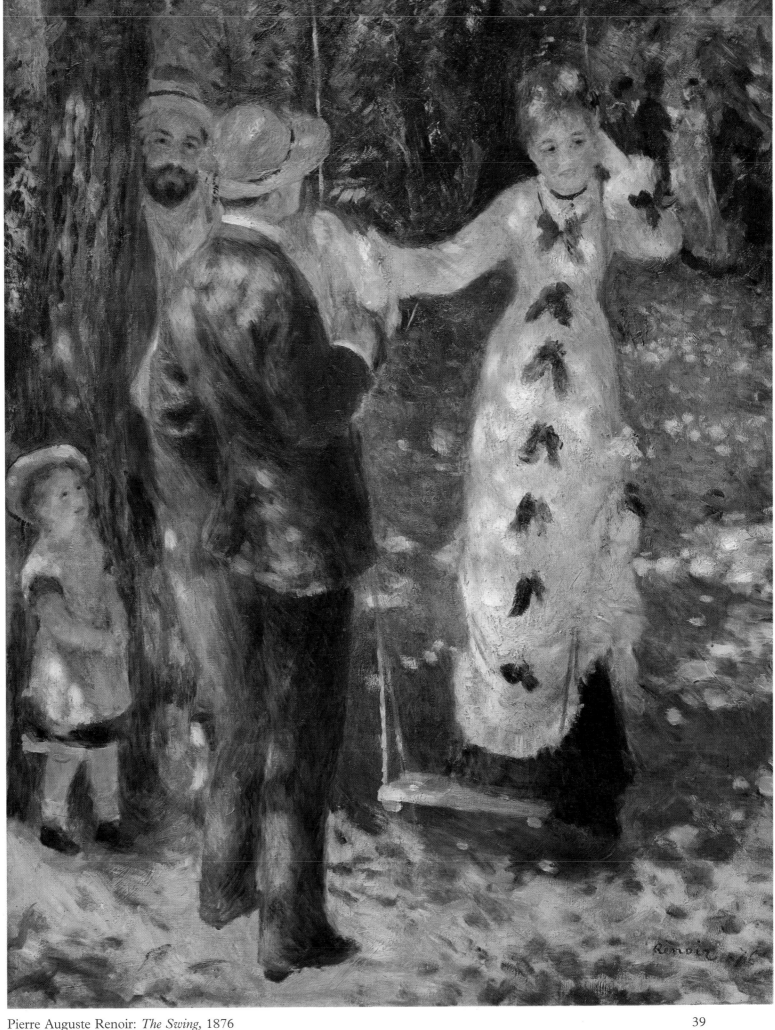

Pierre Auguste Renoir: *The Swing*, 1876

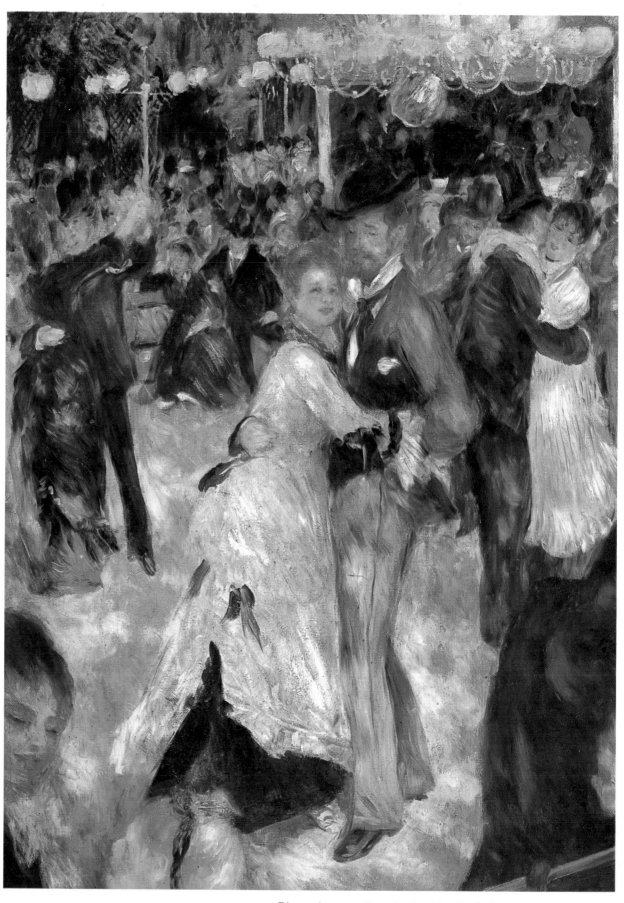

40

Pierre Auguste Renoir: *Le Moulin de la Galette (detail)*, 1876

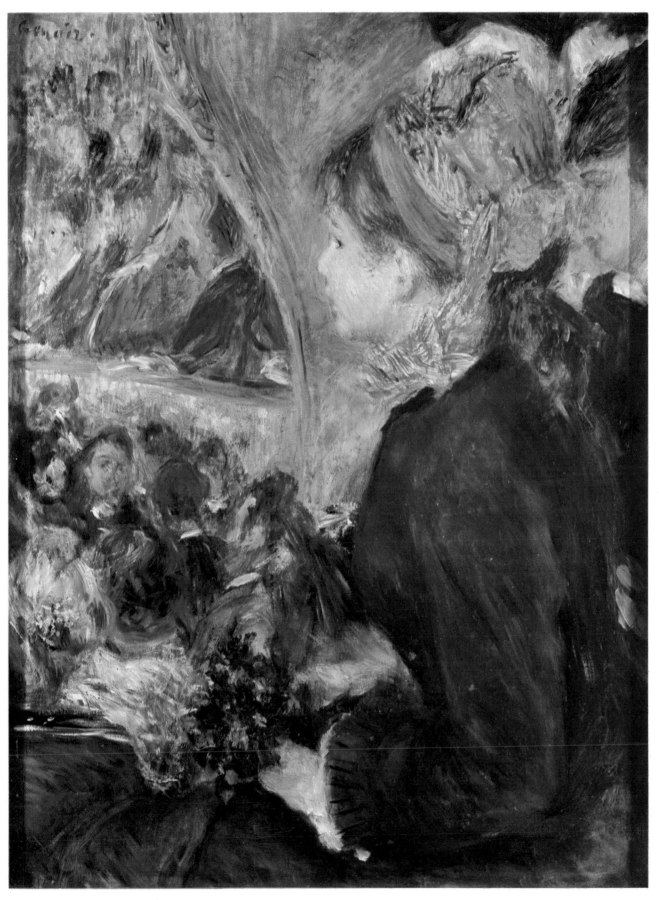

Pierre Auguste Renoir: *The First Outing (La Premiére Sortie)*, 1876

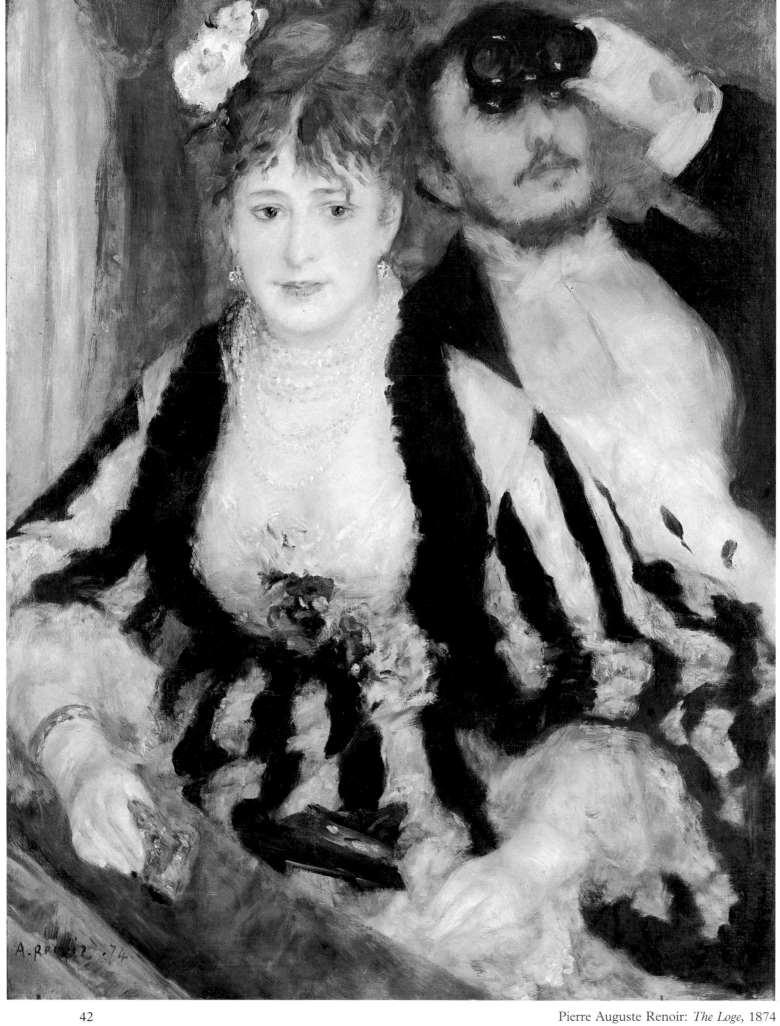

42 Pierre Auguste Renoir: *The Loge*, 1874

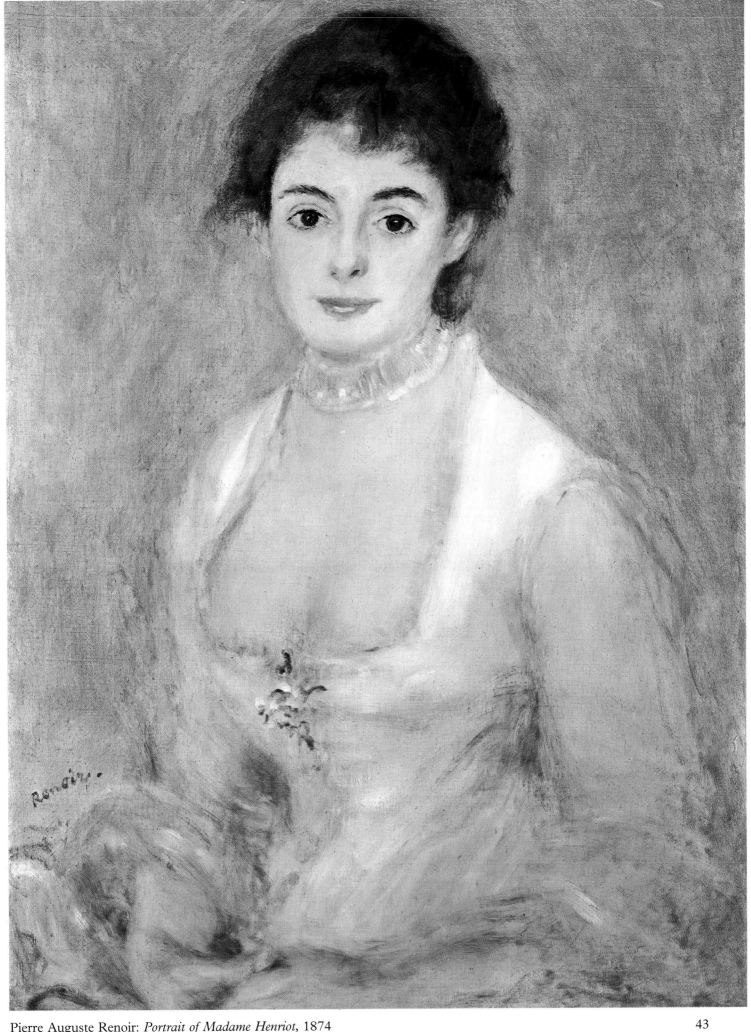

Pierre Auguste Renoir: *Portrait of Madame Henriot,* 1874

43

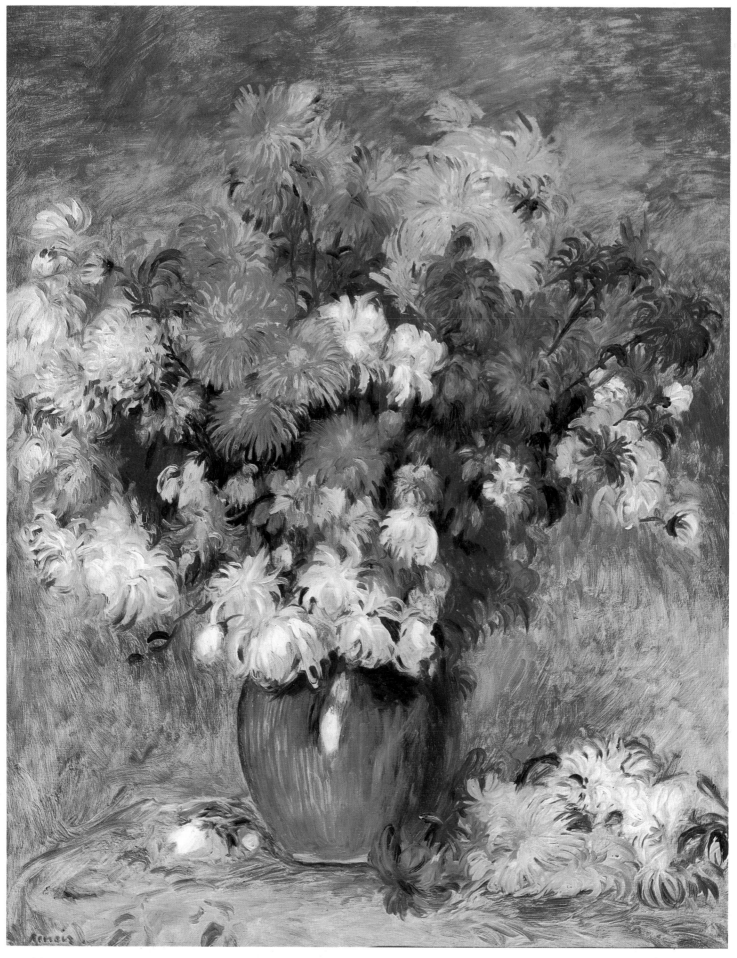

44 Pierre Auguste Renoir: *Vase of Chrysanthemums*

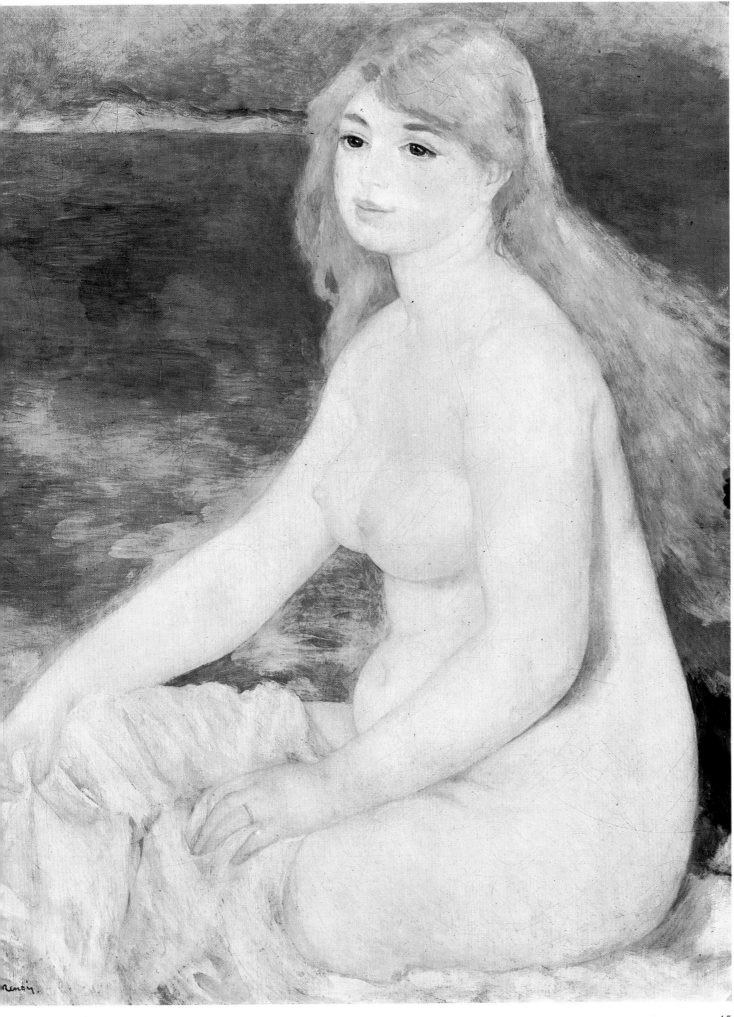

Pierre Auguste Renoir: *Blond Bather,* 1881

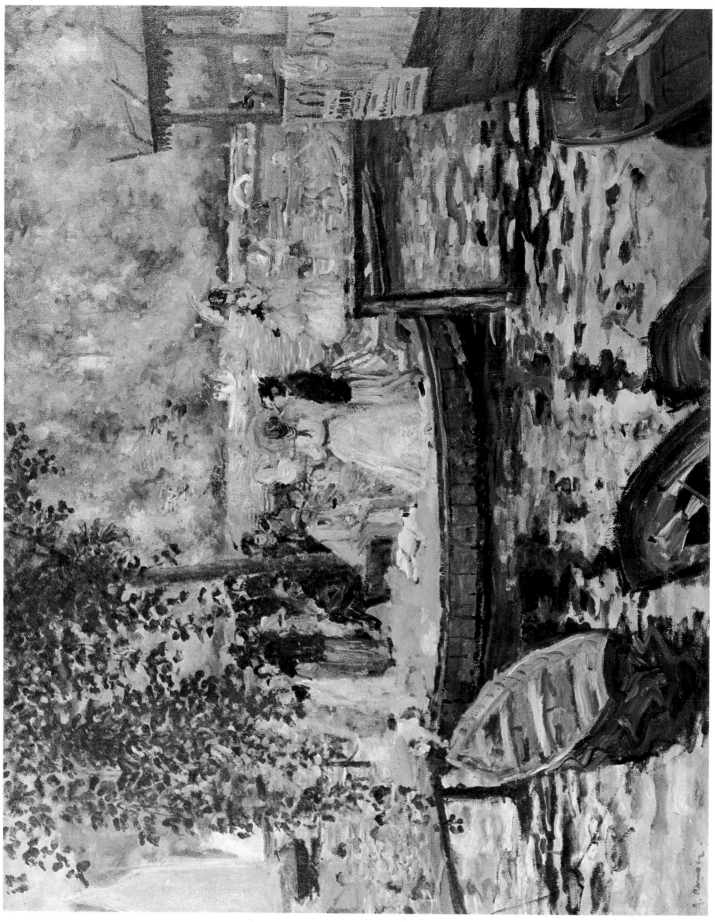

Pierre Auguste Renoir: *La Grenouillère*, 1869

**Camille Pissarro,
Alfred Sisley,
Gustave Caillebotte
and
Armand Guillaumin**

In 1874 Monet and his circle finally managed to set up the first Impressionist Exhibition – to be followed by others, in 1876, 1877, 1879-82 and 1886. Monet was the prime mover, and Degas supported, despite not being an Impressionist himself. Manet, though, did not participate. The thirty-nine artists exhibiting included Monet, Degas, Renoir, Cézanne, Morisot, Boudin and Pissarro.

The show, perhaps predictably, provoked extreme ridicule, to the extent that the works proved unsaleable. The paintings' colors were pronounced by the public "so raw that they hurt their eyes" and the artistic distortions were a subject for hilarity. Another show two years later got an even worse reception. One critic wrote, "There has just opened an exhibition of so-called painting – five or six lunatics – try to make Monsieur Pissarro understand that trees are not violet and that sky is not the color of fresh butter".

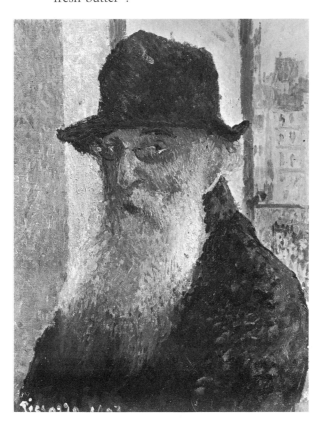

Pissarro: *Self-Portrait*, 1903

Camille Pissarro (1830-1903) was the oldest Impressionist; after Monet, he was the strictest adherent to the movement's tenets. A sober and gentle individual with deeply held convictions, he was first influenced by Corit and then by the more "realistic" approach of Courbet. Pissarro went on to teach and and profoundly affect the work of Cézanne, Van Gogh and Gauguin. In contrast to the other Impressionists, his work was usually accepted by the official Salon, but he made the decision to show only with the group and he alone contributed to all eight Impressionist exhibitions and the 1863 Salon des Refusés.

His works have an outstanding quality of luminosity. Pissarro and his family suffered financial ruin with the Franco-Prussian War in 1870, and, like Monet, he left for England until it was over. Later in life he encountered Seurat and Pointillism but subsequently resumed "less scientific" painting. Although he developed a serious eye condition, Pissarro continued working until his death.

Highly reminiscent of the work of Pissarro is that of Alfred Sisley (1839-99), though he never painted figures, instead specialising in landscapes, especially those featuring water – *The Pont-Martin Canal, Flood at Pont-Marly*, thought to be one of his masterpieces, *The Tugboat* and *The Banks of the Seine: Wind Blowing.*

When residing in England he painted the Thames and the Severn. Another artist adversely affected by the Franco-Prussian War, he had acute financial problems stemming from lack of artistic recognition: he famously exchanged paintings for dinners at Murer the pastrycook's shop.
Letters of Sisley's exist requesting his friends to purchase his paintings for extremely reasonable sums, on the assumption that his work would in time be recognised and they would eventually profit. Ironically, the prices for his paintings did in fact escalate rapidly soon after his death.

There were other artists in the Impressionist group who were highly competent and effective, but not major influences on the development of the movement. These include Bazille, Caillebotte, Cassatt, Fantin-Latour, Guillaumin and Morisot.

Gustave Caillebotte was a gifted amateur painter but owes his chief distinction to his activity as one of the first collectors of Impressionist work. He also helped with and showed at the Impressionist exhibitions.

His collection of sixty-five paintings by Manet, Degas, Pissarro, Sisley, Renoir, Monet, and Cézanne he left at his death in 1894 to the French government, with a stipulation that it be shown in the Louvre. The authorities were, however, embarrassed by this largesse as Impressionism was still considered avant-garde and only a proportion of the works were accepted.

Armand Guillaumin was a close friend of Pissarro and Cézanne, who participated in the Salon des Refusés.

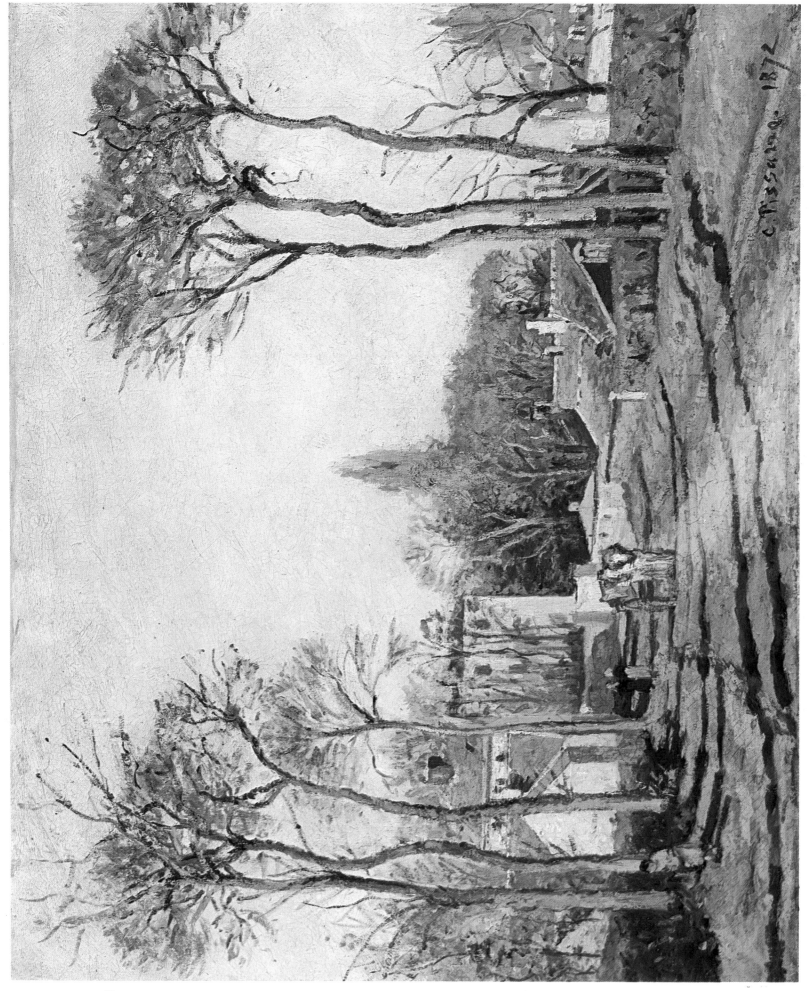

48 Camille Pissarro: *Entrance to the Village of Voisins,* 1872

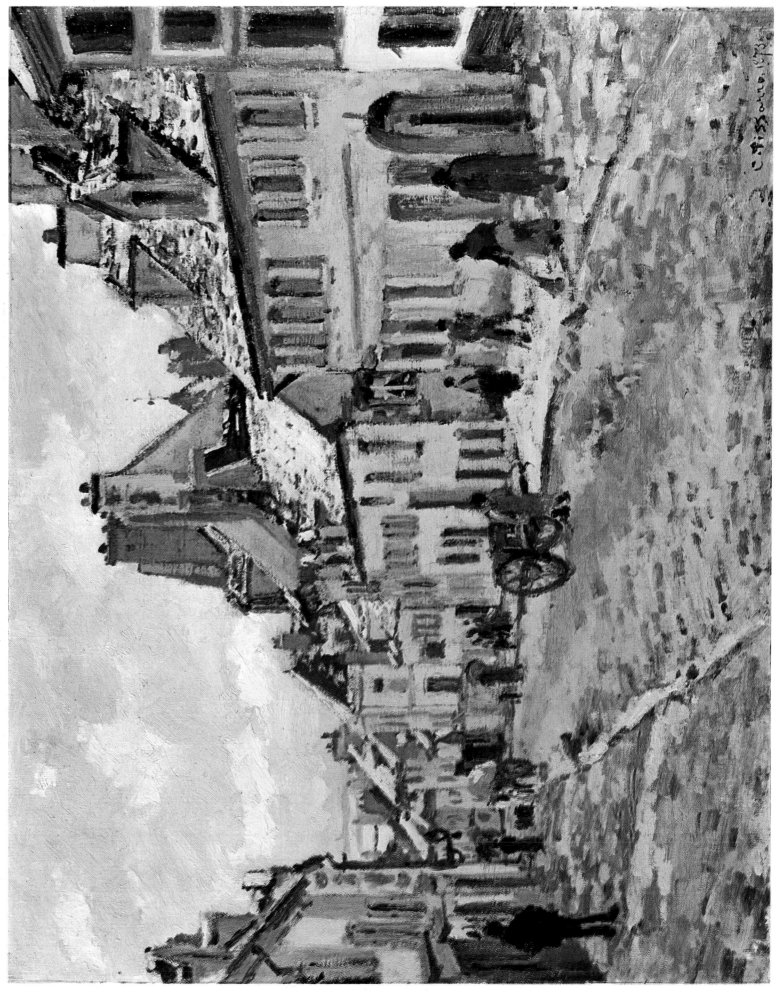

Camille Pissarro: *Pontoise, the Road to Gisors in Winter*, 1873

49

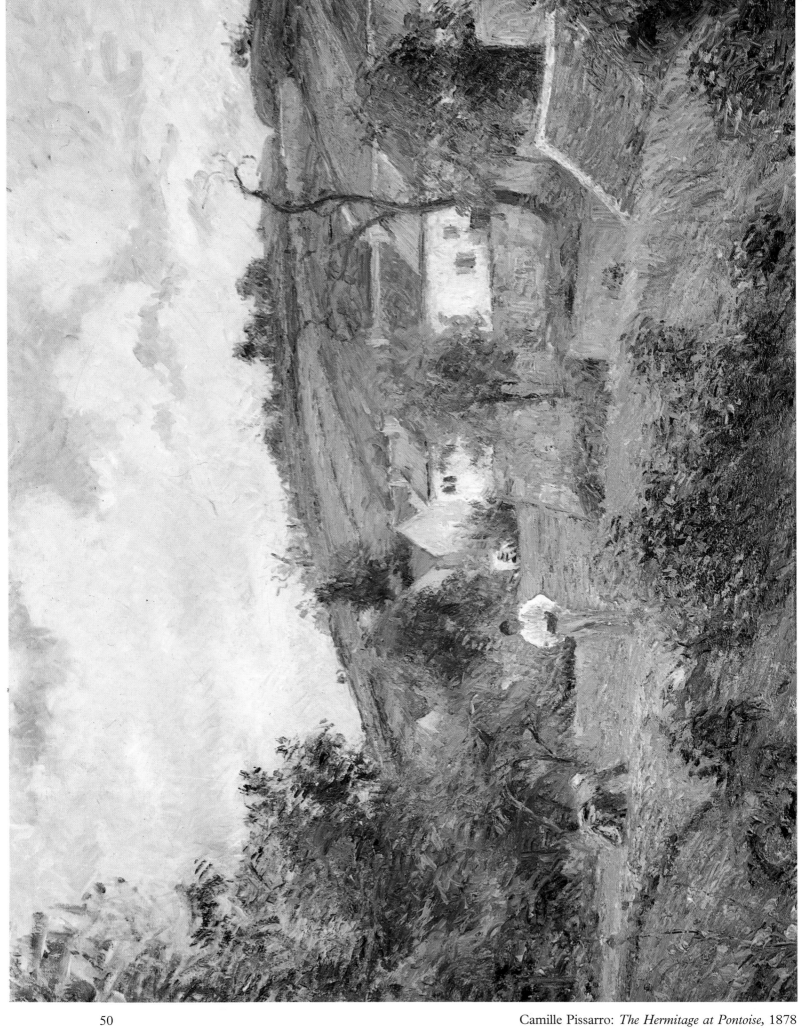

50 Camille Pissarro: *The Hermitage at Pontoise,* 1878

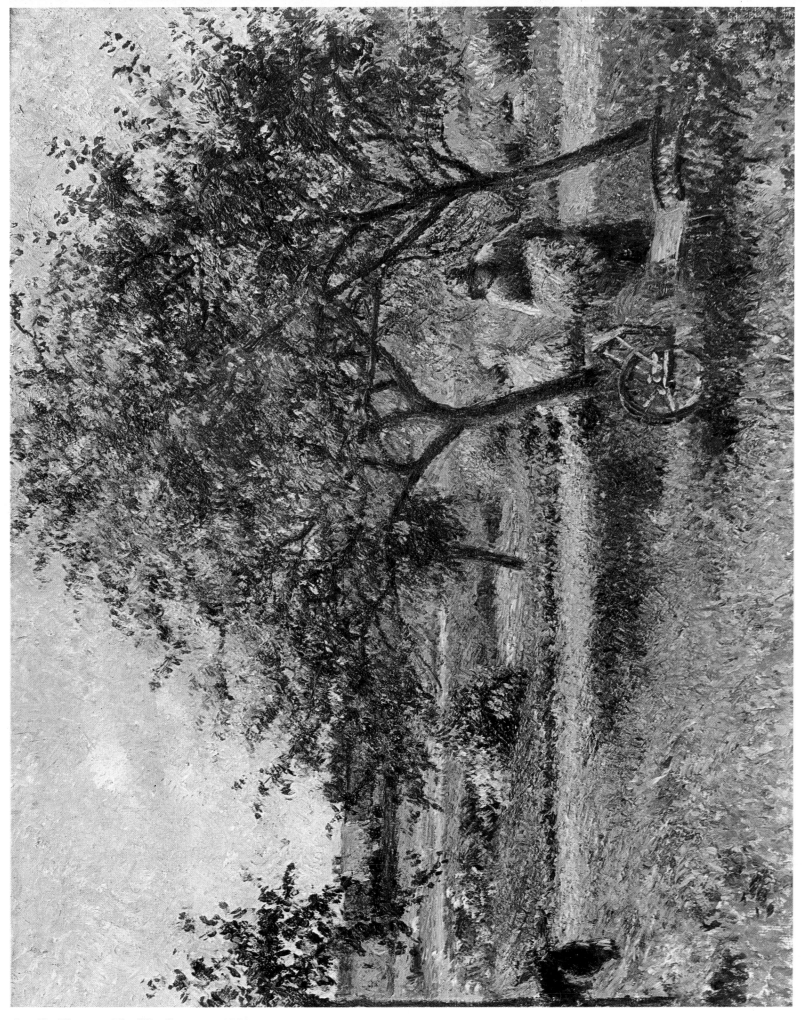

Camille Pissarro: *The Wheelbarrow,* c.1881 51

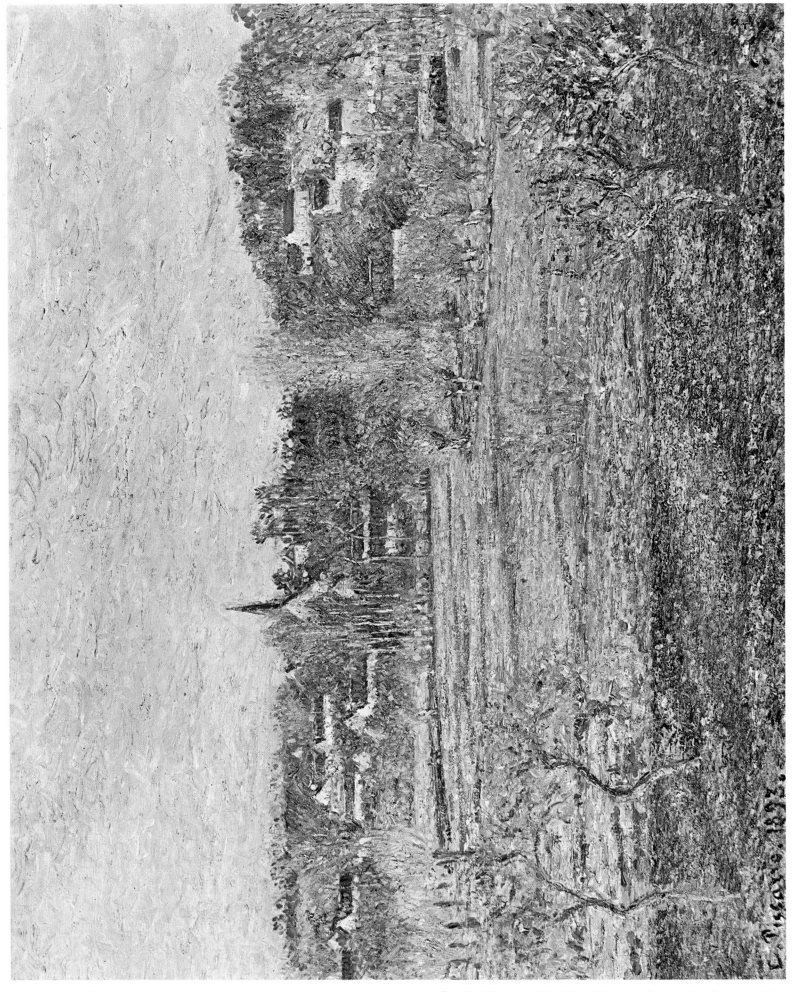

Camille Pissarro: *The First February Rays at Bazincourt,* 1893

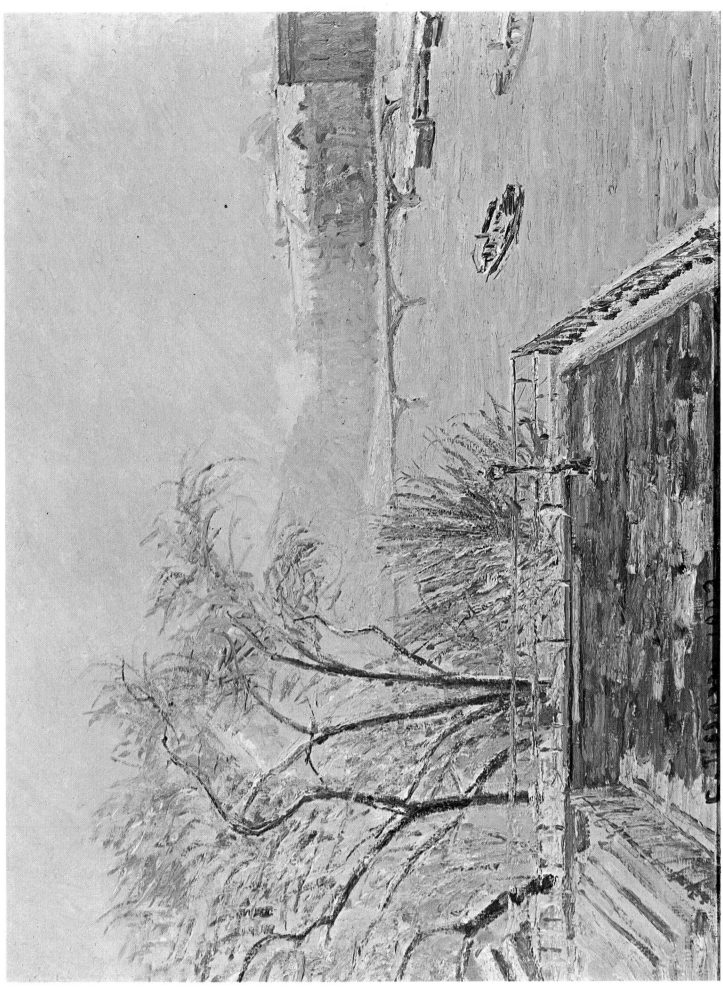

Camille Pissarro: *The Louvre, Morning, Snow Effect,* 1902

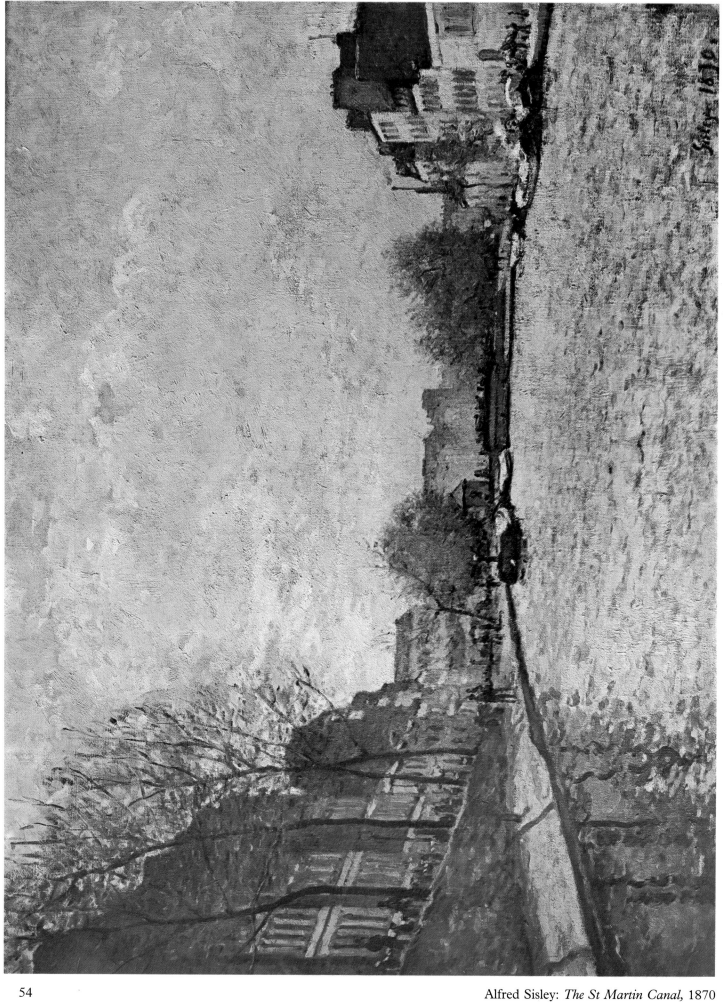

54 Alfred Sisley: *The St Martin Canal,* 1870

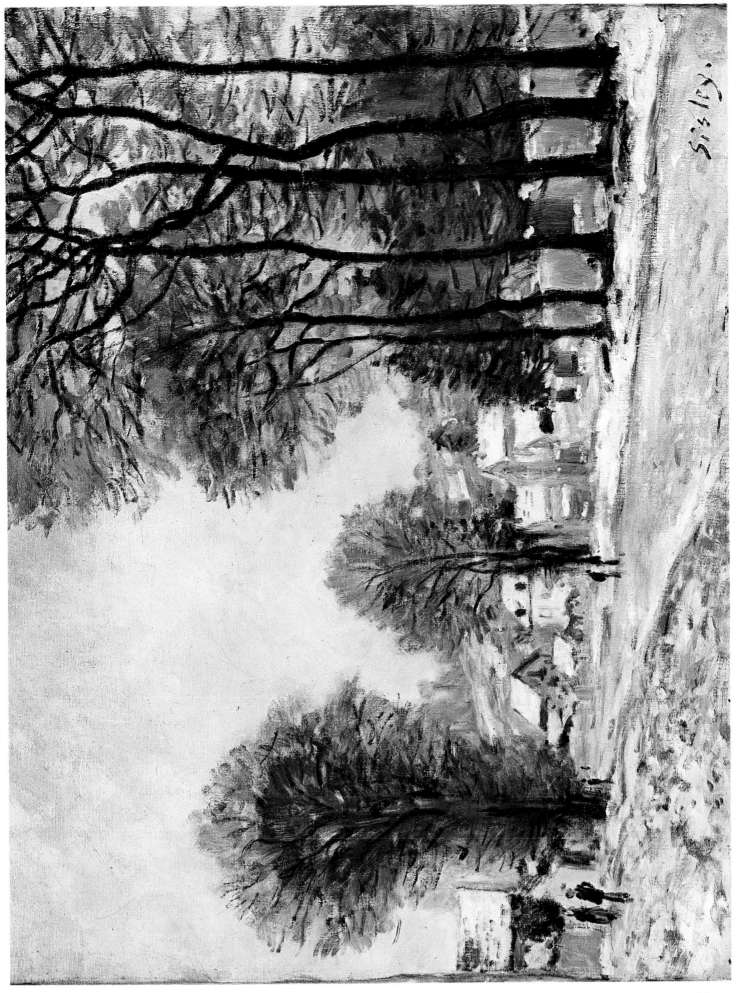

Alfred Sisley: *Snow at Louveciennes*, c.1874

55

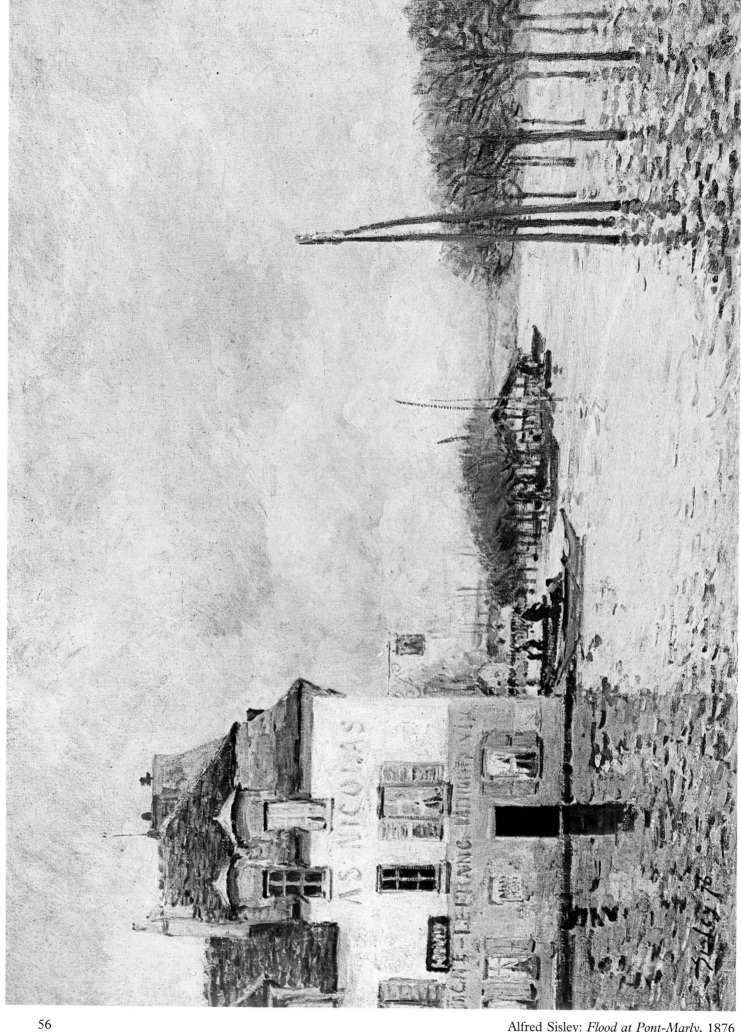

56

Alfred Sisley: *Flood at Pont-Marly*, 1876

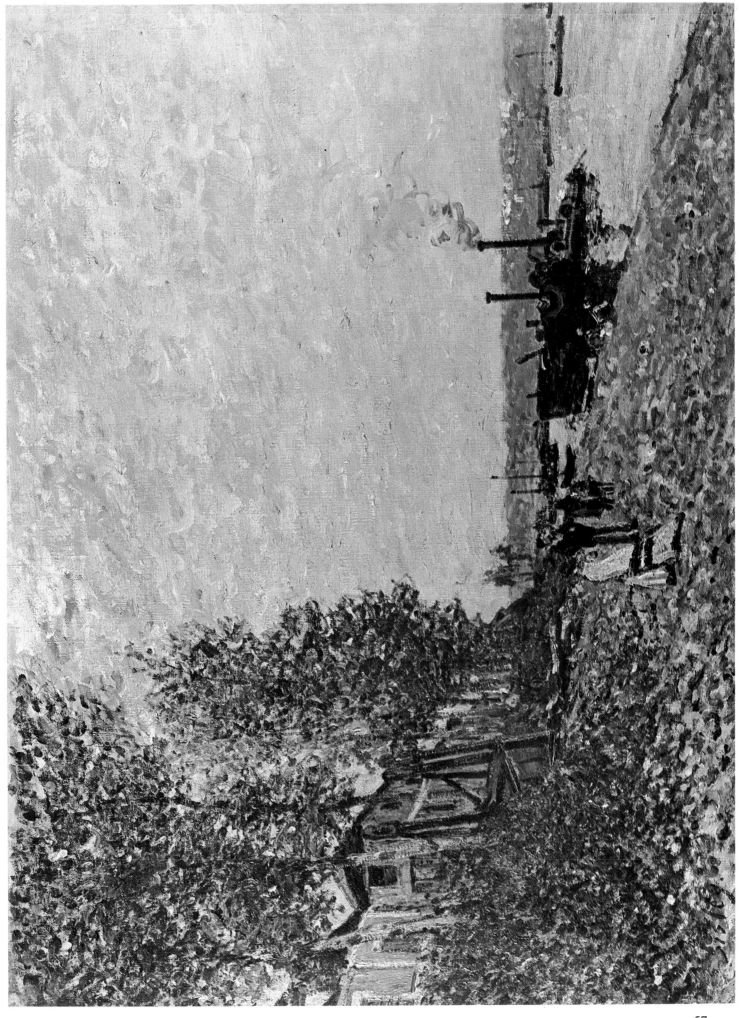

Alfred Sisley: *The Tugboat*, 1883

57

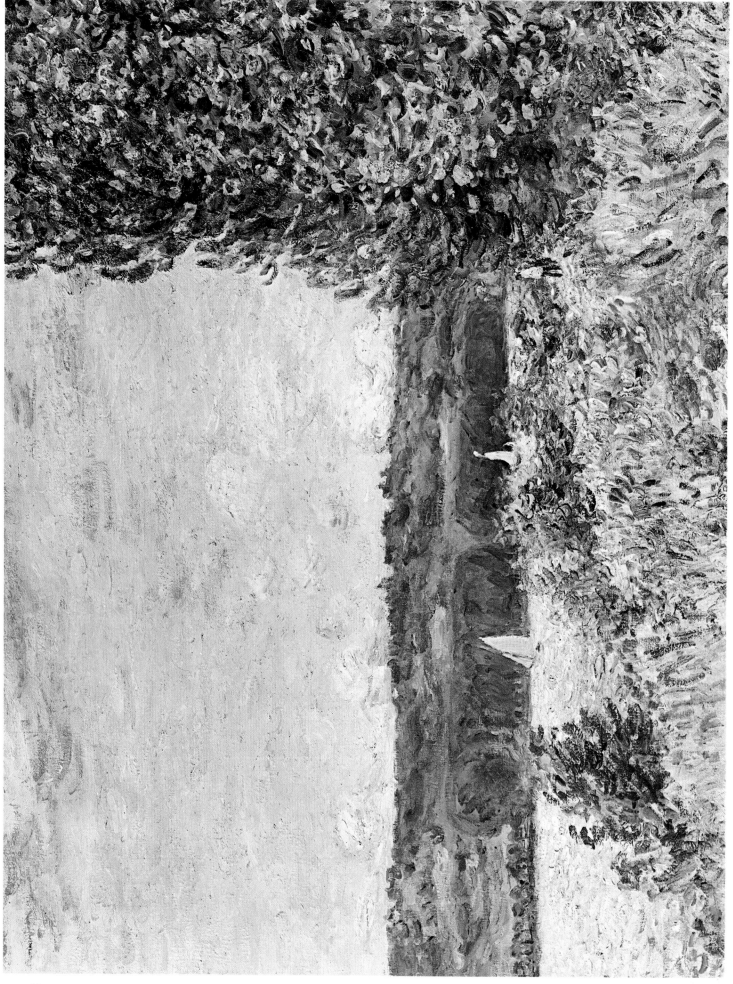

Alfred Sisley: *The Banks of the Seine: Wind Blowing*, 1894

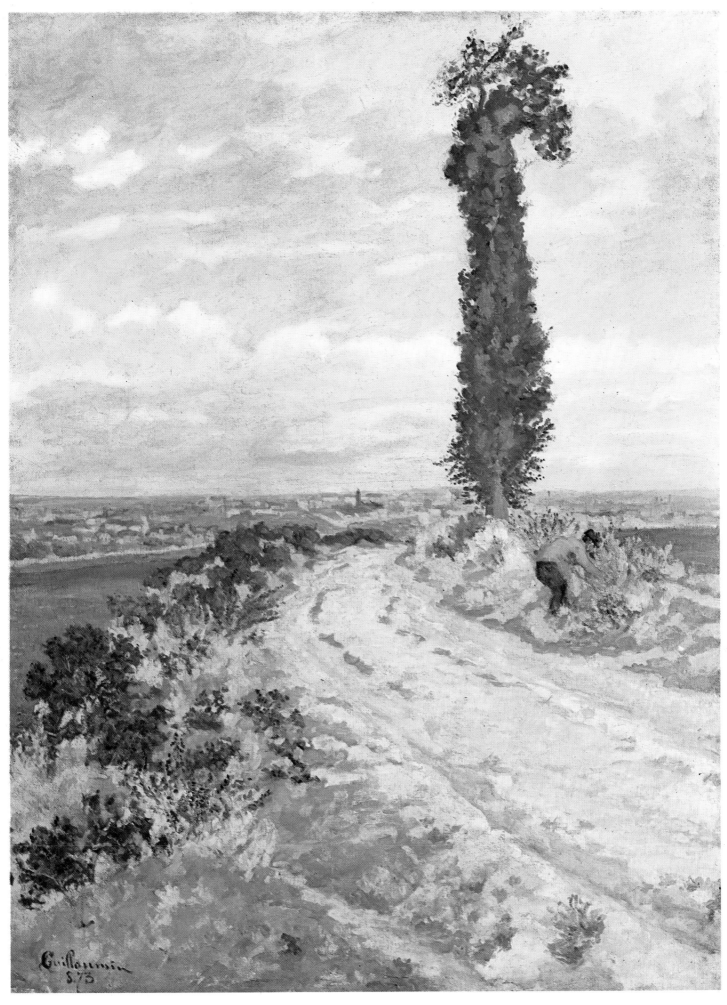

J B Armand Guillaumin: *Outskirts of Paris,* 1873

Berthe Morisot and Mary Cassatt

Two highly gifted women painters were members of the Impressionist group. Berthe Morisot was a pupil of Corot's as she found open-air painting attractive. She was also Manet's sister-in-law and often posed for him (see *Berthe Morisot Holding a Bunch of Violets*).

The subject matter of her paintings is generally feminine or domestic, for example, *Young Woman Sewing in a Garden* or *The Little Girl from Nice* – which contrasts acutely with her strong and energetic style. She had much in common with Degas, who wrote of her, "We have identical intellectual dispositions and an identical predilection for drawing." One of her friends noted, "The interesting thing about Berthe Morisot was that she lived her paintings

and she painted her life. As a girl, wife and mother her sketches and paintings follow her own existence closely....Her work reminds one of a woman's diary written in color and line."

Morisot showed pictures at almost all the Impressionist Exhibitions, and Renoir, Degas and Manet frequently congregated at her home.

Mary Cassatt arrived in Paris in 1874 with six years' artistic study in Europe behind her.

She was instinctively attracted to Impressionism, particularly to the work of Degas, whom she met in 1877; he invited her to join the Impressionist group, with whom she often exhibited, her work concentrating on women and children. She was instrumental in introducing Impressionism to the United States.

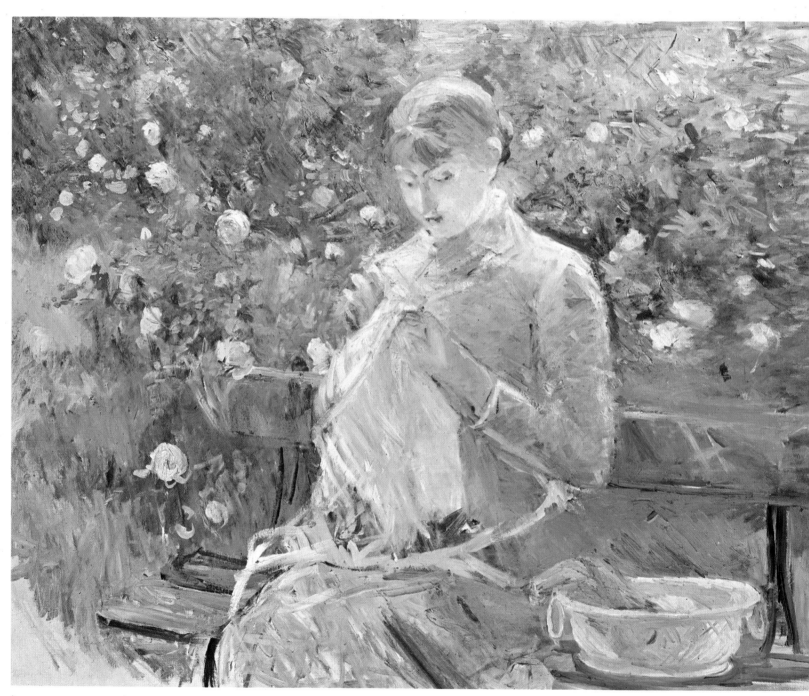

Berthe Morisot: *Young Woman Sewing in a Garden,* 1881

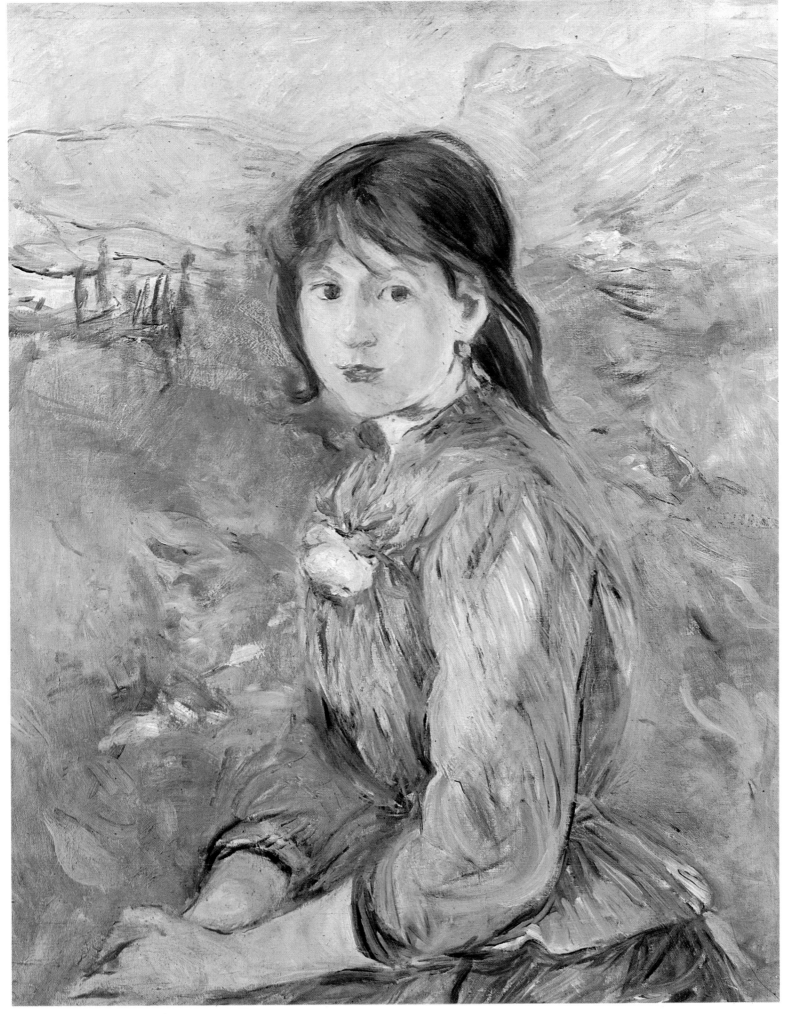

Berthe Morisot: *The Little Girl from Nice,* 1888–1889

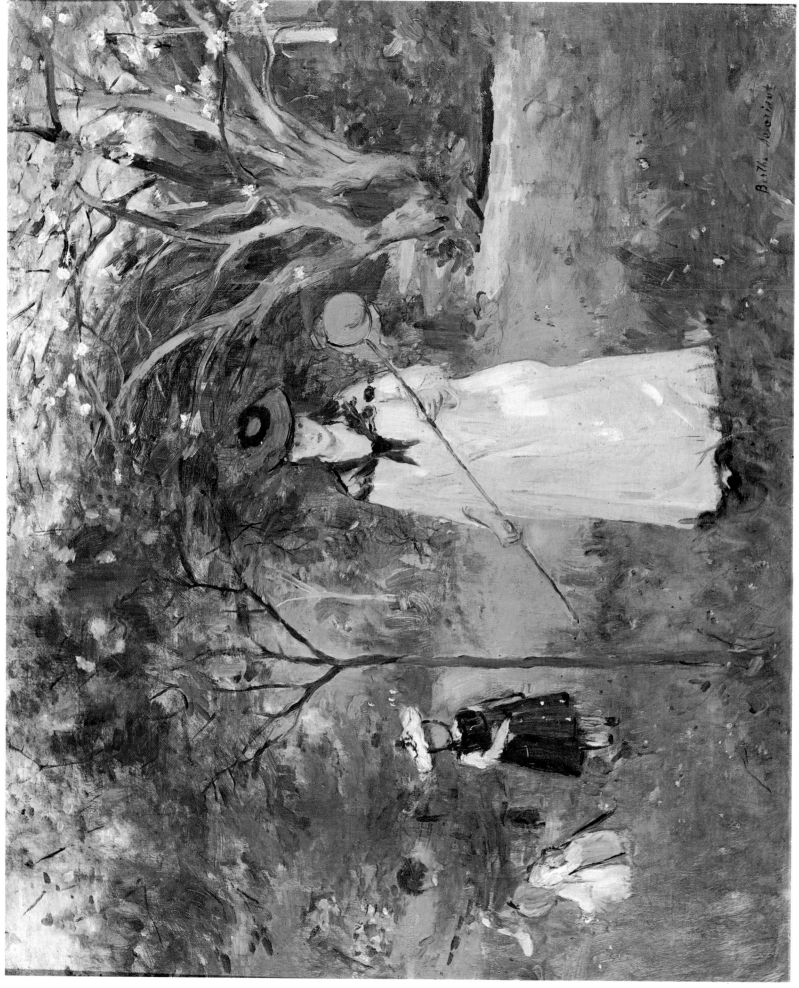

62 Berthe Morisot: *The Butterfly Chase*, 1874

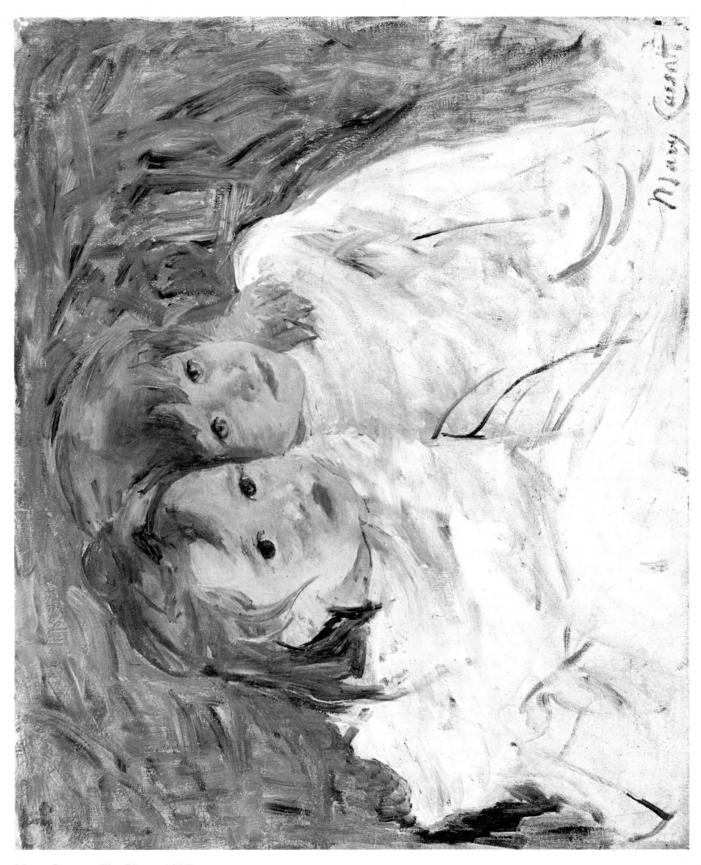

Mary Cassatt: *The Sisters*, 1885

63

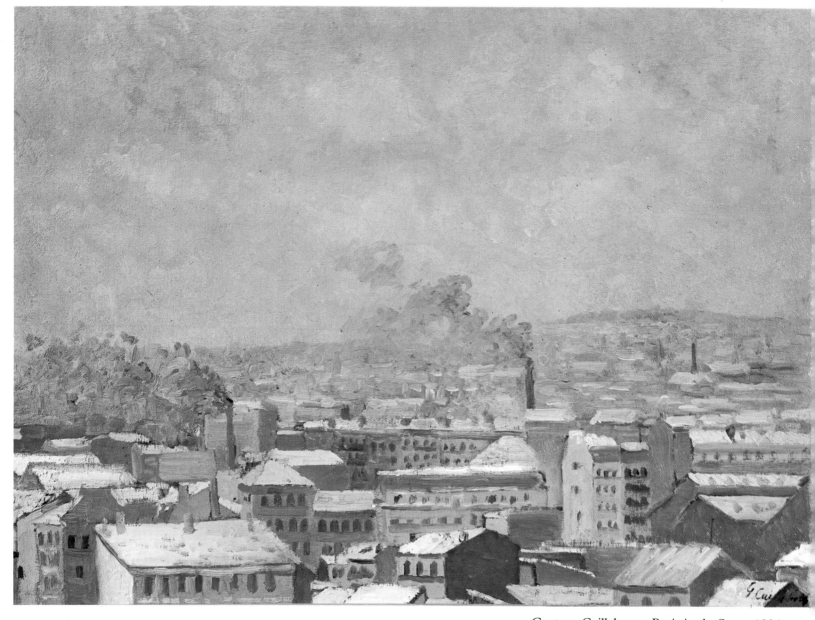

Gustave Caillebotte: *Paris in the Snow,* 1886

What, above all, Impressionism brought to the development of art was the use of pure and bright colors to communicate the effects of natural light. Also, Impressionist design was much more spare and economic, banishing extraneous detail in the speed of execution. As Manet said, "Conciseness in art is a necessity and an elegance. The verbose painter bores. Who will get rid of all these trimmings?"

Finally, the Impressionist painter had a different attitude to the subject: the painting itself was of more significance than what was being painted. Bazille wrote, "In my opinion the subject matters little provided that what I do is interesting as a painting. I have chosen to paint our own age because that is what I understand best, because it is alive, and because I am painting for living people."